Indian Arts and Crafts

Indian Arts and Crafts

Marjorie Miller

Illustrations by
Ann Bruce Chamberlain

Galahad Books • New York City

Contents

1.
Introduction:
The Indian World

The culture of the American Indian is essentially spiritual. His way of life, his thoughts, his art are given spiritual significance, approached and colored with complete realization of the spirit world.

The Indian believes that a Great Spirit animates everything — that He pervades the universe and is the supreme ruler. Not only does man have a spiritual identity, but the stones in the field, the birds and flowers, the rain — all are reflections of the Great Spirit. Thus, the American Indian, throughout his far-flung tribes and traditions, shares the all-pervading belief that man is one with his environment. He is the true ecologist. He reveres all living things as part of himself. When he creates artifacts, he respects the materials of the earth. All have an identity and command that respect — the wood of the forest, the grass of the plains, the clay of the desert.

In the Southwest, that vast colorful region of desert and mesa and mountain, influenced by continuous contact with the Spanish, pottery is an ancient craft tradition. Clay is dug from the earth, coiled and built up into forms – for the cooking pots, water jugs, vessels to hold corn and beans of the rain-worshipping Pueblos; for the ceremonial jugs and medicine pots of the Navajo. The forms are classically pure, since pottery making has an unbroken tradition of over 1,500 years. Many forms are shaped by hand out of the red clay of the earth.

From the earth, too, is the basketry of the Southwest. Flat or coiled yucca baskets, wickerwork trays of rabbit brush or sumac, brightly dyed with earth colors. Reeds, bear grass, willow – bleached in the sun and tinted with dyes of roots or berries to make this unique basketry.

Fetishes – often natural stone formations resembling animals – possess a spirit which gives aid to the owner. In legend, these stones were once the animal they now resemble, turned to rock by certain gods.

A likeness of the Great Spirit is never made, but his messenger, the Thunderbird, his symbol, the Bird-Serpent, or lesser spirits such as Kachinas are a colorful and unique part of the Indian world.

The Indian is a natural artist – sometimes using symbolism for meaning, sometimes painting for the joy of color and design.

In the Southwest, he has painted on pottery, hides, and the walls of his ceremonial chambers. He has, in the last generation, also learned modern art techniques which he adapts to express his pride of ancestry in representational, abstract and neoprimitive painting. The mood is unmistakably Indian.

The Southwest of Arizona and New Mexico is the most important center today for contemporary Indian arts; it is in the Pueblo area, where an ancient lifestyle has changed little, that the richest varieties of traditional arts are to be found.

But across the country, Indian artist-craftsmen are evolving forms which reflect both ancient traditions and a changed way of life.

From the Northeast woods comes the Iroquois heritage. These were woodland people who, in the sixteenth century, hunted and fished and farmed, building warm bark and log houses against the hard winters. These were the great Iroquois Confederacy of tribes — the six nations of Mohawks, Oneidas, Cayugas, Onondagas, Senecas, Tuscaroras.

The crafts of the Iroquois sprang from necessity, as did the crafts of all Indian people. The materials tell of the environment — deerskins and furs, lush grasses, husks of corn, stone and wood. The artists' materials were the flowers of the forest and animals of the woodland — quite unlike the jagged lightning and sun symbols of the desert Indians.

Iroquois today, blending the modern with the ancient, embroider deerskin moccasins with floral patterns in bead-work, weave white oak baskets, and as they have done for centuries, find something of value in materials at hand. A doll made of a cornhusk with an apple face and fur mask is as natural and in harmony with its surroundings as the more austere Kachina doll is in the Southwest, with its cottonwood body and feathers and bright paints of roots and bark.

In the Smokies, that strong race of mountaineers, the Cherokees, farmed and lived in towns built on the basis of brotherhood. They were basket weavers and carvers of ceremonial masks long before the coming of the white man; now there is a revival of their traditional crafts — split white oak basketry, baskets of honeysuckle vine, stone masks and pottery.

To the south of the Cherokee lived four other great tribes: the tall and graceful Creeks, who were devoted equally to music, ball games and war; the Chickasaw, brave and warlike, who warred constantly with neighboring tribes; their close relatives, the Choctaw, who were the most successful farmers of the southern Indians; and in southeast

Florida, the Seminoles, who split off from their brother Creeks and made their home in Florida.

Seminole crafts are as separate as the literal meaning of their name, which means "runaway." Working with materials at hand, they create a patchwork of costuming that is uniquely theirs.

The Indians of the Great Plains hunted buffalo and painted and feathered themselves. They were masters of adornment — featherwork, beautiful stitchery and beadwork that decorated their buckskin clothing, tipis and artifacts.

A profound belief in the Great Spirit did not prevent them from being the most warlike of the Indians. Of the thirty or more groups on the Great Plains, from the Mississippi to the Rockies, the Sioux, the Blackfoot, the Crow in the north — the Arapaho, Cheyenne, Comanche, Kiowa — recall a vivid and romantic past. Their descendants perpetuate the flamboyant spirit in their arts and crafts today, in hide painting and bead work, and in ceremonial objects used in the Native American Church of North America, the revived ancient Peyote cult.

Beyond the Rockies, before the white man, widely scattered groups of Indians lived in arid parts of what is now California, Nevada, Utah and Idaho. Natural resources were few; for food, there were roots, grasshoppers, caterpillars. In California, the acorn. For utensils, not the red clay of the desert or the white oak of the Northeast, but bear grass and sedge root and yucca — scrubby foliage from which intricately woven baskets were made. From a sparse material existence, with harsh, unyielding natural surroundings, there grew a rich, nature-oriented spiritual life.

By contrast, Indians in the Northwest, from southern Alaska to Oregon, inhabited a rich, fertile region between the ocean and the forest. Again, motifs of their highly developed crafts reflected their environment — fish, whales, ships, stylized faces of birds and animals. These were the carvers;

wood was abundant, especially cedar, for building, for utensils, for shredded bark fiber for weaving. Food was abundant and readily available and theirs was sophisticated, ornamental craft work — objects richly embellished with paint and carving.

For over five centuries, the American Indian has come into contact with outside influences, which have brought changes in his ways of life. But despite this, his arts and crafts still carry within their forms traditions that far predate the arrival of the white man, and the mystic spirit which has always pervaded his work pervades it still.

2.
Silverwork

Although silverwork is one of the most famous of Indian crafts, it is not an ancient craft. Pieces of silver and lead were prized, but copper was the only metal worked before the arrival of Europeans in North America.

The Iroquois and other tribes in the Northeast had learned silverworking by 1800. The craft then spread to the Lakes region and west to the Prairie and Plains Indians, where it influenced the development of silverworking in the Southwest. The first silver ornaments that the southwestern Indians used were obtained through trade or warfare with other tribes or with the Spanish. The Navajo then learned the art of silverwork themselves from itinerant Mexican smiths who roamed the Rio Grande valley in the mid-1800s, producing silver trinkets in exchange for horses.

In the beginning, the craft was practiced by the men and the craft was passed from father to son. Sometimes a man from another tribe would pay a Navajo smith to teach him the art; by the late 1800s the Zunis had learned the craft and a few years later there were also silversmiths in other pueblos.

Crude homemade tools were used for these first early pieces. Some were copies of ornaments used by the early Spanish: hollow spherical beads, domed buttons, silver-mouthed bridles and a small pomegranate, which was the forerunner of the famed squash blossom. The squash blossom necklace itself is one of the best examples of an adapted item. It is widely thought of as Navajo in origin. In actuality, however, it derives from a small silver pomegranate which Spanish men wore as ornaments on their trousers and capes. The squash blossom is an elongated version of this ornament. The necklace consists of three parts — the beads, the squash blossoms, and the pendant.

The *naja* — the crescent-shaped pendant — is believed to derive from Moorish designs. It originally appeared suspended from the center part of silver bridles. The Spaniards borrowed the decoration from the Moors in North Africa and it found its way into the Southwest by way of Spain and Mexico.

The word "naja" is Navajo. The ornament was also used both in North Africa and the Middle East as an amulet to ward off the evil eye. It has developed into a variety of forms in the Southwest, but it is regarded as neither charm nor amulet. The naja and squash blossom necklaces are, however, often referred to as symbols of fertility. The white man's imagination created this idea — there is no basis for thinking so, either in Indian legends, beliefs or customs.

Bracelets are one of the most popular ornaments of Navajo jewelry. They are either cast, or cut from a strap of silver and decorated with pieces of turquoise. Casting silver is a technique learned from the Europeans and Mexicans. In the

Southwest, molds for casting are made by carving designs in a fine-grained pumice or sandstone.

As the use of silver by the Indians increased, tobacco canteens, bow guards, buckles and blouse ornaments were created in profusion. Tobacco flasks and powder chargers· were utilitarian items. Buckles, which were either cast or hammered and stamped, were and are usually worn with belts studded with silver "conchas." The origin of the concha probably goes back to hair plates worn by the Plains Indians which the Navajo saw and copied.

The first bracelets and earrings, made around 1870, were hammered out of American silver dollars. Coins provided the sole source of silver until 1890, when such use was prohibited by law. During this period, casting was begun (around 1875) and sparse decoration was done by engraving and by stamping straight geometric designs with an iron chisel. About 1890, steel dies were copied from Mexican leather workers and these were used for stamping silver.

In 1890, the use of dollars was forbidden by law and the Navajo turned to the Mexican pesos, which, in fact, contained more silver. Some turquoise was used, but most of the early jewelry had no stones and was heavily stamped.

Tourist interest in Navajo jewelry was at a peak in 1900, and Navajo work was commissioned in quantities for sale. The Navajo continued using Mexican pesos for his jewelry and this practice continued until 1930, when the Mexican government forbade the export of its coin. To prevent the decline of the craft, white traders bought sterling silver in both slug and sheet form from silver refineries to sell to the craftsmen on the Navajo reservation. The Indians have at no time mined their own silver.

As in other Indian crafts, the coming of the railroad influenced the product. Until the 1890s, the silverwork produced was for sale or trade with other Indians. The white man's arrival with the railroad created a second market. Curio

stores were created. Orders from these companies created a demand — for pins, bracelets and rings, decorated with arrows, swastikas and thunderbirds. Spoons, cuff links and tie clasps were ordered from Indian craftsmen, who obliged by making these items.

The use of turquoise increased as it became available in greater quantities. Experiments with decorations had been tried earlier by the Indians. Glass, jet and garnet as well as the turquoise stone have been used, but turquoise proved to be the most popular and the use of other materials was gradually discontinued.

While the Zunis cut and polish their own stones, most of the turquoise used is cut and polished by non-Indians and furnished to the silversmiths in *cabachon* form, that is, a stone without facets, ready for mounting. In pre-Spanish times, turquoise was mined with hammers of stone, or picks made of antler. Fire was used to crack rock containing the blue gem. The largest of the early mines was located near Cerillos, New Mexico. Turquoise today is mined on a small scale in Colorado, New Mexico, Arizona and Nevada. None of these mines is owned by Indians.

The two markets, Indian and non-Indian, continue today. A Navajo silversmith may wear a Zuni bracelet with elaborate clusters of turquoise himself, while producing a fine heavy sand-cast bracelet for a non-Indian customer.

Silversmithing is one of the few crafts at which the Indian artist can earn a living, and some Navajo and Pueblo silversmiths work full time at the craft. For most, however, it is a part-time occupation and provides a relatively small part of their total income.

The quality of the work being produced today is at a high level. New and better tools are available and the craftsman himself is striving to improve both design and technique.

3.
How To Make Navajo and Pueblo Jewelry

A piece of Indian jewelry reflects the man who made it — his own individual skill as an artist and craftsman and the aesthetic and religious values that are a part of his culture.

In the earlier days of the craft, the Indian silversmith used as his tools metal that he picked up here and there — old iron buggy tires, discarded railroad spikes, etc. Working silver is quite simple and the Indians found they could do many things with it they could not do with other metals. Silver softened with heat. When softened, it could be beaten into sheets and brooches, buckles and bracelets cut from those sheets.

Buttons, halves of beads and the rounded plates used to decorate belts could be made by hammering sheet silver into wooden forms.

Designs could be made in the soft silver by tapping with a

punch or iron die. To engrave, the silver might be scratched with an iron awl.

An important piece of equipment was a forge, used to melt the silver. The Indian constructed his forge with pieces of broken pottery or stone, cemented together with adobe clay. The forge had a homemade bellows. To solder, he used a gasoline blowtorch. The anvil most commonly used was a section of rail, or any chunk of iron. For hammering, an old claw hammer or a mechanic's hammer from some automobile tool kit; a cheap pair of pliers or two for holding and bending; and for snipping, a pair of old shears. The Indian silversmith made dies and punches from whatever pieces of metal could be found, and he prized his collection highly.

An ideal workroom for the craftsman who wants to do silverwork will include an anvil, the block on which metal objects are hammered into shape. Anvils may be purchased in some hardware stores, or a trip to the country may reward you with an old blacksmith's anvil.

A gas blowtorch supplies the heat necessary for softening silver. A small portable gas tank may be purchased which is equipped with a hose and different-sized nozzles. Use either illuminating or fuel gas.

You will need hammers. A rawhide hammer is useful, but a wooden mallet will do as well.

Also needed are tools for cutting the silver:

1. A chisel – a sharp-edged tool used for cutting or shaping not only silver, but also wood or stone
2. Tin shears – large scissors used for cutting tin and other soft metals
3. Cutting pliers
4. A jeweler's saw

Any of the above tools can be used to cut silver. The cold chisel is the simplest to use, but has the disadvantage of possibly cutting the face of the anvil.

Several types of pliers will be needed. For flat work, you should have flatnose pliers, and roundnose pliers for wire. Wire can be cut with side-cutting pliers. Tin shears should not be used to cut wire.

Jeweler's saws can be purchased with an adjustable frame. The saw should be about 6 inches deep and more than one blade will be useful — ranging from No. 2/0 to 1/2 or 2.

The Indian works with an array of files. Work with jewelry requires files that are not too coarse. Needle files are needed for the more elaborate pieces of jewelry. To begin with, a flat file, a half-round file and round file are sufficient.

If you wish to make rings, you will need to invest in a ring mandrel, which is a long tapered piece of round steel with ring sizes marked on it.

A small hand drill is necessary.

Punches and dies include a dapping die for making hollow beads and hammering up half spheres. If you wish to, you may make them as the Indians did years ago — of hardwood, using a metal punch. Depending on the skill of the craftsman, punches may be bought or made from material around the shop, such as pieces of steel that are no longer useful. The novice will do best to purchase his, remembering that while the Navajo prizes highly the handmade punches with which he stamps designs in his silver, he also avails himself of any modern equipment he can obtain. There is no particular virtue in using handmade tools, except that the Indian craftsman in using his is more concerned with the piece of jewelry as a whole than with perfection in small details.

In addition to the tools required for silverwork, the silver itself is necessary.

Pure silver is too soft for ordinary jewelry work, except for making bezels, the little rims soldered to jewelry to hold the settings. Sterling silver is the best to work with and can be purchased wherever jeweler's supplies are sold. Sterling silver is an alloy of 925 parts pure silver and 75 parts copper. It comes in sheet and wire form and in varying thicknesses.

Silver is usually sold by weight, but it is well to know the gauge you want as well as the dimensions. The type of jewelry you plan to make, will, of course, determine both. Good standard gauges of sheet silver are 16, 18 and 20 gauge; 16 gauge is approximately 3/64 of an inch thick while 20 gauge measures about 1/32 of an inch. An exception is in making bezels; these require a heavier piece and 26-gauge silver is about the right thickness.

A good practice width is 6 inches, the usual length for a bracelet. Rarely do other pieces of jewelry exceed that length.

Silver wire is also necessary. It, too, varies in thickness. If you have or intend to purchase a drawplate, then only a couple thicknesses of silver wire are needed. Order only 14 or 16 B & S gauge wire. A drawplate enables you to draw the smaller sizes of wire as you need them. Otherwise, you should include thicknesses ranging from 14 to 30 gauge.

Silver that has been annealed — that is, heated and then allowed to cool slowly to prevent brittleness — is easier to work with. Silver wire has generally already been annealed; inquire before you purchase.

Silver Soldering

Silver soldering is the process of joining two pieces of silver together. The solder itself is the material used to form the joint; it is a metal alloy which when melted connects the parts. No matter how well the parts of the jewelry have been designed, filed, shaped and fitted, if the parts are not successfully soldered, the completed piece will be shoddy and inexpertly made.

Flux is also needed in the soldering process. This is a substance which is used to help metals fuse together. Borax and water are frequently used. Purchase the borax from a supply house. About ten minutes before you intend to begin

the soldering process, place a small amount of borax in water. A solution will be formed which will prevent the silver from oxidizing – necessary because silver solder will not adhere to an oxidized surface.

Neither will silver solder adhere to a greasy surface. The parts that are to be soldered must be clean before the soldering process is begun. Either file or scrape the area of the metal where the solder is to be applied.

It is best to experiment with different solders and fluxes before attempting to solder your piece of jewelry. This will acquaint you with the action of the flux, the solder, and the silver.

Sterling silver melts easily. Make little silver raindrops as a beginning exercise, saving them to use later on for decoration. These are the materials you will need:

1. A piece of 20 gauge silver about 1/8-inch square
2. A charcoal block
3. Flux
4. Sulfuric acid solution (1/4 acid to 3/4 water)
5. Copper tweezers

Place the silver on the block, put a drop of flux on it and apply the flame. When it has rolled into a small ball, let it cool and then drop it into a small dish of the sulphuric acid solution. The resulting little piece of silver will be white and round with a slightly flattened base.

Now that you have experimented with flux and solder, and have practiced making raindrops, you are ready to begin your first soldering.

These are the materials you will need for the first step:

1. Borax (either powdered or stick)
2. A slab of slate with a depression in it
3. A piece of silver about 1 by 1 1/2 inches
4. A charcoal block
5. Powdered pumice

First, make your flux. Either form a paste from borax by first placing water in the crevice in the slate and rubbing the borax stick around; or, make a borax and water solution with powdered borax. Next, take the piece of silver and place it on the charcoal block. Place a drop of the borax solution on the middle of it. The flux should stay put. If it creeps, the silver is greasy and must be cleaned. Use the powdered pumice for cleaning. When the piece of silver is sufficiently clean, the flux will not move.

For the second step in the operation, you will need:

1. A piece of silver 1/2 by 1/4 inches
2. Gas blowtorch
3. A file

First place the 1/2- by 1/4-inch piece of silver on edge against the larger pieces of silver. File the piece so that it will stand at right angles to the base piece.

Next, apply flux to the bottom edge and up the sides for about 1/16th of an inch.

Take the silver solder and cut two small pieces and coat them with flux by placing them in the borax solution in the slate slab. Then lay them at the joint.

Apply heat. The heat should be applied gradually. Heat applied too quickly will cause the solder to jump away from the joint because the heat forms steam which throws the solder out of place.

There should be plenty of heat while soldering, but the heat should not blow. Indian silversmiths use their blowtorches to solder small pieces as well as large. To acquire the skill takes practice.

An important point to remember is that the flame should be kept moving at all times, the heat being applied gradually. You will know if you have applied the heat too fast — the solder will melt and form into balls. The desired effect is for the water to evaporate slowly, the silver becoming red hot

and then the solder, instead of balling up, will flow along the joint. You will notice that solder also follows the heat.

The soldering operation is what makes a silversmith a skilled craftsman. It needs careful handling but with practice it can be done skillfully and correctly.

4.

How To Make Silver Rings without Settings

Solid silver rings without settings are a good project to begin with. They can be finished in 4 to 6 hours.

Materials needed:

1. A ring that fits, or a ring gauge if you have one
2. One strip of 18-gauge silver, 5/16-inch wide, and 1/16-inch longer than is needed for the finished ring
3. Stamping punches (a straight liner and a small diamond stamp)
4. A pointed scriber
5. A file
6. A ring mandrel
7. A small wood hammer
8. A thin file
9. Thin, black, annealed iron wire
10. Flux (borax and water solution)

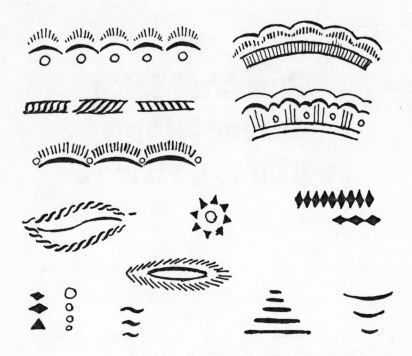

Figure 1

Figure 2

First, measure the finger that the ring is to fit. Cut the strip of silver 1/16 inch longer than the length you need.

Next, study the design you have chosen. (See examples of Indian die designs, Figure 1, for ideas.) A simple geometric design is an easy one to start with (Figure 2). Measure 1/16 of an inch from each side and scratch a line the length of the silver from each edge. Using a straight liner and a hammer, make the two long grooves along the scribed lines. Then stamp in the diagonal lines. After the diagonal lines have been punched, round or square off the edges with a file. Use the small diamond stamp for the center design.

After the edges have been filed and the ends squared, shape the ring over a ring mandrel. A round piece of metal or wood will also work. Use a small wooden mallet for the shaping.

Try the ring for size. Soldering is the next step and you should inspect the joint where the ends meet to be sure the edges are even. If they are not, take a thin file and smooth down the edges until they are even.

Next, take the thin black wire. This is to be used to tie the ring together (Figure 3). Make certain the ends are clean. Apply flux on the ends before wiring.

Soldering

Place the ring on a charcoal block. Put more flux on the joint and put a small amount of solder over it. The solder should also have flux on it.

Apply a medium flame slowly. The silver will turn dark. Watch for the flux and solder to melt.

After the solder has hardened, take off the iron wire and place the ring in a solution of 1/4 sulphuric acid and 3/4 water to dissolve any flux that may still be sticking to it. Then rinse the ring in clear water, dry it, and touch up the joint with a fine file.

Figure 3

Polishing

If you have a buffing wheel, use that with crocus compound. An old toothbrush dipped in powdered pumice will polish as well. Take care not to polish off too much of the stamped design. The file marks should be removed by filing, but silver is soft and if care is not taken the stamping will be polished off too.

About Silver Rings

The custom of wearing metal finger rings by the Southwestern Indians was probably in imitation of the European custom. The earliest rings were made of thin silver and were simple in design. The practice of mounting stones was rare and the use of turquoise did not occur until later. As the Indian silversmiths progressed in technical skill, the complexity of form and design increased. In some instances, the jewelry became overly ornate and the good taste of classical lines was sacrificed.

Rings may also be made by the casting process. A strip of silver is first cast flat, then reheated and bent into a circle, and finally the ends are soldered together.

5.
Silver Rings with Stones

The perfection of two techniques is necessary in order to make a ring with a setting. One, the art of making silver bezels (the metal holders into which the stone is set) and, two, the art of setting the stone itself.

Bezels may be high or low, and the size of the bezel is determined by the size of the stone you wish to use.

Materials needed for the first step in making bezels:

1. 26- to 28-gauge sheet silver
2. Soldering frame
3. Blowtorch
4. Powdered pumice
5. Iron wire (optional)

Pure silver is best for making bezels because it is softer than sterling or coin silver and doesn't melt as easily. The

28-gauge silver, which is thinner, is used for small bezels and the 26-gauge for larger ones.

The piece of silver must first be annealed. Heat it until it is bright red and then allow it to cool slowly. The silver will then be soft and pliable. Clean it with fine pumice and water.

Next, twist one end of the silver around the stone you wish to set in order to get the approximate size of the bezel. Cut off any surplus silver. Then form the bezel to the shape of the stone. Leave a little clearance so the stone will fit without being forced. Check to be sure the ends of the bezel come together accurately in order that it will make a good solder joint. As with finger rings, it may be necessary — particularly in the case of a large bezel — to wire it together first before soldering. With experience you will know when and when not to use the wire for binding.

Soldering

Materials needed:

1. Solder
2. Flux
3. Blowtorch
4. Files

The bezel may either be first soldered and then attached to its base, or, the two steps may be combined in one operation.

If you choose to do the soldering in two steps, first solder the bezel as you would solder a small ring. Soldering in this manner will insure a good fit. If your bezel is 1/2 to 3/4 of an inch in width, however, it is usually a good idea to solder the bezel itself and attach it to the base in one operation.

One-Step Soldering

Match the bottom of the bezel to the base to which it is to

be soldered. It should be a perfect fit. If not, file the uneven places with a flat file.

On the inside, place the solder snippets, about 1/4 inch apart. On the joint, lay a snippet against or over the joint on the inner side. The piece of solder you use for the joint should be at least as high as the bezel.

Apply flux, and play the flame on the work. Take care not to heat the bezel more than you heat the base or the solder will run up on the bezel because solder follows heat. The opposite will happen if you heat the base more than the bezel. So, by making certain that both base and bezel are heated evenly, the solder will flow evenly around the base and along the joint.

Mounting the Stone

Usually the base upon which the bezel is to be attached will be a level surface. If it is not, the bezel should be filed to conform to the base or support. The top edge of the bezel should always be level. When mounting a stone in a bezel that does not have a flat base, a riser should be inserted inside the bezel to give the stone a solid and level base all the way around (Figure 4). Sometimes a piece of silver wire which has been bent to fit around the inside of the bezel will be enough

Figure 4

to set the stone to the proper height. This is frequently done in a case of a low stone and a high bezel.

Another method of setting a stone involves the use of cardboard which is cut to fit inside the bezel. The stone is set over the cardboard into the bezel. Then the top of the bezel is gently forced against the stone. This can be done by clamping the ring in a vise, using something soft like leather to prevent scratching, and a small wooden mallet or a pusher to force down the bezel. The upper edge of the bezel should fit closely all around the stone.

Even up the edge of the bezel by smoothing it with a small file. The cardboard is used to absorb any shock as the stone is forced into the bezel.

The Stone

Stones should be set into the bezel last, when everything else is finished, since heat will crack or discolor turquoise. Turquoise matrix, the markings caused by the mother rock in which turquoise is found, also cracks easily when dropped or when hit hard. If you should break a stone, it can be cut up and ground into smaller stones or, sometimes, an attempt can be made to cover the crack. A design may be made of silver, laid flush with the setting and twisted to fit the crack, and then soldered where it touches the bezel.

To remove a stone from an old setting, run a sharp knife around the inside of the bezel in order to spread it enough to get out the stone. Take care, however, because sometimes stones chip along the edges when running the knife point along them.

6.
How To
Cut and Polish
Turquoise

Most Indian silversmiths do not cut and polish their own turquoise, with the exception of the Zuni Indians, whose work with the blue-green stone is extensive and very beautiful.

Cutting and polishing your own turquoise allows for latitude in designing your jewelry. If you are purchasing turquoise rough, it is well to know something about the varieties of turquoise and its properties, although both the color and markings of the stone are a matter of personal preference.

Turquoise is a hydrous aluminum phosphate colored by copper salts. It is considered a semiprecious stone and is generally found in the arid regions of the world. It is valued in India, Persia and China as well as in the American Southwest. Although it is valued primarily for personal

adornment, the turquoise has at times in history been used as an offering to religious idols; occasionally it is used by the Navajo in their sandpaintings.

The stone is found in veins in other rock, having been deposited there by the action of water. It is the matrix, or mother rock, that causes the markings in turquoise — the characteristic brown or black blotches, the highly-prized spider-web matrix, the bits of quartz or iron pyrites.

The color of turquoise ranges from a pale chalky blue to a dark green, with many gradations of color in between.

The color, the hardness of the stone, and the matrix determine the price, which may range from a few cents per carat to several dollars.

In addition to their durability, hard stones are preferable because they are less likely to change colors. The colors of softer stones will gradually change to a dark green as the result of repeated contact with soap and body oils.

Once you have selected and purchased the stones you wish to use in making your jewelry, the next step is to cut and polish the rough gems for mounting. Most of the work can be done on a small hand grinder. A power grinder works too fast; the hand grinder can be turned with one hand and the turquoise, fastened to a stick, can be held in the other. Since the wheel needs to be moistened with water, the slower speed of the hand grinder will prevent water from being splashed.

Equipment you will need to assemble for the first step:

1. A small hand grinder
2. A piece of rough turquoise
3. Water, in a sponge, or in a bottle with nozzle attached
4. Wood skewers or similar sticks of wood
5. Sealing wax
6. Shellac, stick form (optional)

Position the hand grinder. Wet the wheel, using the sponge or squirt bottle. Hold the rough stone against the wheel with

your fingers and grind off enough to make a base. Wet the wheel as you are grinding, taking care not to get it too wet in order to prevent splashing. The use of water on the wheel keeps the stone from becoming too hot to hold. It also prevents heat which might crack or discolor the turquoise. The side of the rough stone that you have ground off will serve as the base or bottom of the gem.

Now fasten the stone to what is commonly called the lap stick – the wooden skewer or wood dowel rod or whatever similar stick you have chosen. Sealing wax will hold the stone in place; apply the wax first to the stone. Stick shellac melted together with the sealing wax will give a stronger cement. After application, allow the wax to cool before using the grinder.

Holding the stick with the rough stone attached in one hand, work the hand grinder with the other. First, grind away only the rough part of the stone without wasting any of the good turquoise. Try to get as much good stone out of the rough piece with as little waste as possible. Next, there are two possibilities. If you know by having already worked out your design exactly what shape you wish, then proceed to grind down the stone on the face of the wheel until you have achieved that shape. Otherwise, aim for the shape which would emerge with the least possible waste – round, oval, square, oblong, triangular. In this case, your design will be determined by the shape of your stone.

Material needed for the next step:

1. An abrasive cloth (180-grit)

The use of the abrasive cloth is for additional cutting. Place the cloth on your knee and smooth the turquoise to a uniform surface.

Materials needed for polishing the stone (this is the final step in preparing the turquoise for mounting):

1. A strip of heavy canvas
2. Tin oxide

Rub the tin oxide into the canvas and then tack one end of the canvas to the edge of a table. Form a trough by pinching together the other end of the canvas and rub the turquoise, still cemented to the stick, through this trough. Turn the stone while rubbing and in a few minutes you will have a high polish on the gem.

In order to remove the stone from the stick, first heat it, then twist it loose. Use a knife carefully to cut away whatever was may still remain on the stone.

7.
Concha
Buttons

A button is the easiest thing to make with silver. The Spanish word *concha* derives from the Greek, referring to the spiral, one-piece shell of certain sea mollusks. Concha buttons are replicas of the larger conchas used on belts.

The southwestern Indians used buttons almost entirely for decorative purposes.. Rarely if ever were buttons used to hold parts of clothing together. The first buttons were made by forcing disks of metal into a hollowed-out form by pressure from a die with a rounded head. This gave a shape like the head of a cane, a dome-shaped affair. The technique was improved and instead of undecorated surfaces, silver buttons were filed, embossed, stamped and even cast.

Concha buttons are made in a variety of sizes and designs. Only one soldering operation is necessary — attaching the

loop to the back. The concha button, which is to be sewed onto cloth, has a small loop at the back, while the concha used on a belt has a narrow metal strip to allow for the passage of the strap of leather.

Materials needed for making concha buttons:

1. 20-gauge silver
2. A round object
3. Tin snips
4. Files
5. A moon-shaped die
6. A straight die
7. An anvil
8. A block of wood

Using any round object such as a coin or another button, mark around it onto the silver. Mark as many circles as buttons are desired.

Cut out the disks with tin shears. Shape up the edges of the disks with a file.

The first stampings should be done on the anvil. Taking the first button, lay on a smaller circle and quarter the outer area. Then bisect the quarters. Take a small moon-shaped die and stamp around the smaller circle and between the radial lines. The third finger of the left hand holds down the disk.

With a straight die, stamp the radial lines. File the petals with a square file. Lay the disk face up on a block of wood and hammer the lines down still more. The petals should now begin to have a rounded shape.

The next step is to make a shallow depression in the end grain of the wood block. Use a round stamp to accomplish this. Turn the disk face down and bump the center slightly, until you have the shape you want. To finish the button, file any marks caused by hammering.

Soldering

The aim is to attach a loop to the back of the button. Take a small piece of silver and cut it to the desired length. File off the ends so that they are square. Next, scrape clean the areas on the back of the button where the loop is to be attached. Wire the loop into place with thin black annealed wire which will be removed when the soldering is completed. Place flux and two small bits of solder at each end. Place the button on a charcoal block and apply heat. Be sure to apply it evenly on both areas until the solder begins to flow.

After cooling, polish the button.

8.
Concha Belts

The Navajo silver belt is made up of conchas strung on a leather strap. Sometimes oval and sometimes round, both forms have in common a certain basic pattern. On the edge of the concha is a decorated area with scalloped edges which has around its inner edge a narrow zone of tooling.

The decorations on the outer edge tend to be widely spaced while on the inner margin the decoration is continuous and sometimes in relief. The uniformity of design suggests that the original design was stamped into the silver from a particular ornament or type of ornament which silversmiths saw and admired. Some feel that the silver hair plates of the southern Plains Indians were the original model. There is also speculation that silver conchas of Spanish or Mexican origin served as the inspiration. A pair of cast silver conchas of Spanish or Mexican origin were excavated in

southern New Mexico along with some badly rusted spurs. These conchas had scalloped edges and an adjoining narrow zone of more minute decorations, the same type of treatment which seems to have been duplicated later on the Indian belt concha. The conchas excavated contained open work requiring a high degree of technical skill. It seems probable that before the southwestern Indians adopted silversmithing, an ornament of this type was made in the Spanish colonies. The early Indian craftsmen lacked the skill to reproduce ornaments of this type exactly so the thought is that either the Indian took over the general idea or there may have been a less ornate Spanish version, which was capable of being copied more exactly.

In the excavated conchas there was a central opening which was divided by a bar, used for attachment to a strap (Figure 5). This feature is also found in early Indian conchas. With time, in place of the opening itself, the Indian silversmith began to place a decorative feature from which a variety of design treatments radiated. Instead of using the old diamond-shaped central opening as a means of attachment to a beltstrap, Indian conchas have a metal strip which is soldered to the underside of the concha itself (Figure 6). However, in spite of the change in the central portion of the ornament, the traditional scalloped marginal band and its bordering narrower companion band have remained basically unchanged.

The traditional style of heavy silver concha belt has been modified somewhat in recent years to accommodate non-Indian tastes. Turquoise mountings have been added, along with ornamental silver trinkets which alternate with the conchas themselves. This results in a lighter belt than the traditional one, which was found by some to be too cumbersome and heavy.

A characteristic concha has a fluted sunburst in the central part (Figure 7). These are usually made with a punch and die.

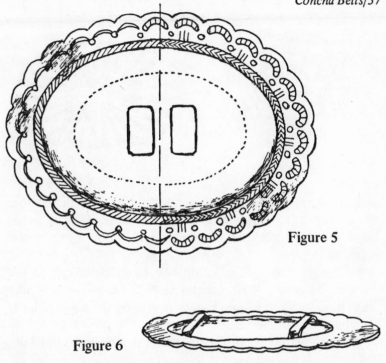

Figure 5

Figure 6

The punch is filed to shape first and then hardened. Then another piece of iron is heated to a white heat and the punch is hammered into it. It takes many repeated heatings and stampings until the entire face of the punch has been sunk into the die. If a complete die is not available, the sunburst is fluted by hammering up each section separately; examination of these conchas readily reveals many irregularities.

Occasionally an old type of concha will have a sunburst that has been added later. Some have as many as 24 to 30 separate flutes. Generally, however, the sunburst is "bumped up." Sunbursts with wide fluting can be bumped up on the concha (Figure 8). The sunburst is made separately and then soldered on. They were made by hammering down the radial lines in rather heavy silver and filing the flutings. The ends

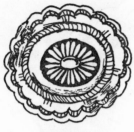

Figure 7

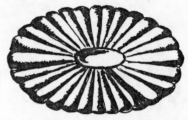

Figure 8

were then rounded and scalloped with a file and the bottom filed smooth. The sunburst is hammered or bumped up in the same wooden form used to bump up the concha and then is soldered in place.

Sunbursts with wide fluting can be bumped up on the concha, however. Most concha belts are made in a similar way. Buckles vary, however, and frequently do not match the conchas used on the belt.

After the sunburst or central design has been bumped up, the rest of the concha is not difficult to make.

First, cut out the oval and file the edges.

Next, lay out the line to mark the edge of the bumped up section and a second line outside of it to mark the width of the inner margin design. If a rope border is used, for example, then rope design.

Next, decide on the design for the border. Divide the oval in quarters with a pencil, lay out the spacing for the border stamping, and stamp the design. Next, file the scallops to conform with the half-moon stampings.

If you would like to make an old-style concha, with openings in the center, use your jeweler's saw and cut the two openings for the belt. Smooth off with a file.

Then, hollow out a block of wood to the depth you desire and bump up the center of the oval. Raise the center about 1/4 inch. Then, turn the concha face up and tap down the

rim with a piece of wood and a hammer. No soldering is necessary in the old style concha.

If you have made a newer style concha with a closed center, then you will need to solder copper loops onto the back of the concha. Make the loops a little narrower than the belt strap. Then solder the loops in place.

9.
Kachina Dolls

The Kachina doll is made by Indians of the Southwest —
the Zunis, some of the Pueblo Indians along the Rio Grande,
but most importantly by the Hopis of northern Arizona. The
small cottonwood dolls are carved by the men during the
winter months and are given as gifts to the children.

Unique and colorful, the Kachina doll may be fashioned
from a slab of wood or made from small pieces of wood
fitted together with tiny wooden pegs. It may be dressed in
miniature costumes of cloth, leather and wood or it may be
painted and decorated with feathers. It may be slender, with
attached movable arms or it may be carved from a solid block
of cottonwood, with only nose, ears and horns attached. It
may be conventionalized in style or it may be naturalistic.

But however constructed, these small wooden dolls are
among the more colorful aspects of the Kachina cult, whose
ceremonials comprise the heart of the Pueblo religion.

According to Indian belief, Kachinas are supernatural beings who, while not gods themselves, are messengers of the gods. The main function of these beings is to bring rain to a people who live and have lived for centuries on semiarid land. Kachina dolls are representations, both of the Kachina spirits, and of masked dancers who impersonate them. The dolls are carved for children, and are not considered sacred — rather, they are viewed as educational toys whose function is to teach the children the shape, form, color and symbolism of each of the 250 Kachina spirits.

The Kachina is an old concept, but the Kachina doll is not. It seems probable that the carving of the Kachina dolls — if not originating then — was influenced by the Indian's contact with Catholic saint statues. The early Spanish friars took great pains to teach the art of carving to the natives. No small part of the assigned task of these native carvers was the making of numerous statues of the various saints. The colorful "santos" of New Mexico are an excellent example of how Spanish-American artists developed a style of their own in this type of religious art. It would certainly seem probable that some Indian artists would transfer their skills from Catholic art in wood to embellish or more fully develop the Indian ceremonial artifacts of wood.

The similarities between the Kachina doll and the Catholic saint are striking. The Kachina doll's function in the Hopi religion roughly parallels that of the saint in the Catholic religion. Each serves as a go-between for mortals and more important dieties. Many people are astonished to learn that the Hopi have 250 Kachinas, whom the dolls represent, and cannot imagine why there is a need for so many. The Hopis fail to understand why Christians should have need for their 30,000 saints.

The earliest type of wooden Kachina was a flat, non-sculptural doll, 6 to 8 inches long. Made from a single piece of cottonwood, it was smoothed down by rubbing on coarse

stones or by filing, with only a slight amount of carving to indicate the break between the head and shoulders. Wooden ears, nose or horns were added as needed, plus a few feathers. The characteristic body painting was a series of three, five or seven vertical red lines, with shoulders and forearms painted alternately in green and yellow. The arms in these early dolls were almost never carved, being indicated by painted lines, and the kilt, legs and feet common in modern dolls were not shown.

From the present evidence available, it seems that the type of Kachina doll most familiar today, the stylized Kachina figurine, developed during the middle and late nineteenth century. The type of workmanship suggests that the rounded carving of the doll was not a sudden novelty, invented by one man and then picked up immediately by others, but something which had been in a process of evolution for some time and perhaps several generations.

Most of the Pueblo Indians make various types of these small wooden dolls but the Hopi Kachinas have become most familiar to non-Indians. Rio Grande Kachina dolls are not so realistic as the Hopi figurines. The Rio Grande carvers indicate only the masked head, leaving the body a plain cylinder. Mask details, such as nose, ears, feathers are added, but the overall appearance is crude when compared to the more skillfully made Hopi product.

The Zuni Indians, who used to carve more of these figurines than they do today, more nearly duplicated the Hopi style but with several noticeable differences. Zuni dolls wore clothes – miniature costumes of cloth, leather and wood. The Hopi artist indicated costumes by painting them on.

Zuni Kachinas were more slender and less stylized in concept and usually equipped with movable arms. The Hopi carver worked from a solid block of wood and only attached features such as nose, ears and horns.

Since 1900, a greater change has occurred. A sophisticated style of carving has developed. Many dolls are carved in naturalistic poses instead of the traditional conventionalism.

And what of the Kachina legend itself, and the Kachina cult that developed from it?

According to Hopi legend, the Kachinas were spirit-beings who came up from the Underworld and roamed the face of the earth, finally settling at a place near what is now Phoenix, Arizona, to make their homes. With them in their ascent from the Underworld were the Hopi Indians.

These Kachinas were good spirits and their powers were awesome. With their elaborate ceremonies, they brought rain for the crops and were in general of much help and comfort to the Hopi Indians.

One day, however, as the legend goes, the Hopis were attacked by enemies, and in the battle all of the Kachinas were killed. Their souls returned to the Underworld, but they left behind their sacred masks and costumes. The Hopis began to impersonate the departed Kachinas, wearing their masks and costumes and imitating their ceremonies, in order to bring rain, good crops and happiness into their lives.

The Kachina cult – belief in Kachina spirits, ceremonial function of masked Kachina impersonators, and carving of Kachina dolls – developed gradually and has come to be a remarkable expression of the art of religious pageantry. It is shared by the Zuni Indians of New Mexico and by some of the Pueblos along the Rio Grande; its most widespread acceptance, however, is among the Hopis.

Every year from Christmas to the Fourth of July, the Hopis stage colorful religious festivals known as Kachina dances. As many as 800 performances, and sometimes more, are given in the several villages atop the high Arizona mesas, either underground in ceremonial kivas or in the village plazas.

These ceremonies are performed for reasons which are

deeply important to the Hopi; they are not identical each year. They are staged, somewhat as a theatrical dance might be staged, with a director, a cast of dancers, and eight or ten new songs made up for the dancers to learn.

There are hundreds of different types of Kachinas dances and each has a set rhythmic pattern. The dance movements, therefore, are traditional and the songs must be made to fit them. The mask and costume for the particular Kachina is also determined by convention and the sponsor of the dance is responsible for the correct costuming of the dancers. A typical costume includes, in addition to a mask, a collar of evergreen, a kilt and sash and moccasins.

When a Hopi dancer is fully costumed, he becomes identified with the Kachina spirit he is impersonating. In this role, prayers of the people can be directed to him.

The dances are performed from sunrise to sunset, and the performances are divided into parts which correspond to the tunes in the song cycle. A song and dance is performed, then a rest period, and then another song and dance.

Sometimes the dancers carry gifts with them into the plaza. They are given to the crowd in general or to individuals. These gifts are considered to represent gifts from the gods and are gratefully received. These include gifts of food to respected village elders – three-lobed loaves of Pueblo bread, pumpkin pies – and Kachina dolls – those small effigies of Kachina spirits – to the children. These brightly colored dolls, presented to Hopi children by Kachina spirit impersonators who dance in the village plazas, are taken home and displayed from rafters and walls to help the children learn to identify the distinctive mask and costume of each Kachina spirit.

The panoply of Kachina spirits includes about 250 beings who range from a gift-bearing Santa Claus-type to a ferocious black ogre who disciplines disobedient children. Some Kachinas are identified only by their ceremonial roles

(runners and clowns). The runners challenge the men of the village to foot races and reward them with gifts if they win. Young boys are encouraged to become good runners, for if the Kachina wins a race, he may cut the loser's hair or rub his face with soot. Clowns perform antics for the spectators at Kachina dances to relieve the solemnity of these occasions. Sometimes the clowning is used as a method of social control by subjecting a villager who has misbehaved to public ridicule.

Many Kachinas represent animals, plants or flowers, insects, places, objects or people. Each has a name, often that of the item it represents: owl, roadrunner, wolf, horse, cricket, Sunset Crater, rattle, snow or thunder. Often the name cannot be translated or is merely the distinctive call of the particular Kachina.

Sometimes a Kachina is identified by some idiosyncrasy in costume or behavior. Many of the female Kachinas, a role played by the men also, provide musical accompaniment with gourds and rasping sticks for the dancers.

There is no fixed number of accepted Kachinas. New ones are introduced almost every year during the Kachina ceremonies. However, they only return the following year if they have developed a popular following or have brought about some good effect. Some of the well-known Kachinas include:

Anakchina — popular Kachinas, they wear long cotton strings from the tops of their heads to which feathers are tied. Known as the "long-haired" Kachina, the Anakchina is one of the most commonly-performed Kachina dancers. Each has an attribute and has a tool or trick.

Chakwaina — this Kachina, known as a horrible ogre, is said to represent Esteban, the first European to enter Pueblo country.

Corn Kachina — this one has a face in three colors: the upper

part is white, with horizontal black lines for eyes, a band of turquoise with a yellow base, and a red tubular mouth in the center. It has square ears, and is decorated with eagle feathers.

Humis Kachimana – these Kachinas represent sisters, sweethearts, or girl friends.

Koyemsi – these are the Mud Heads, the Hopis' ancestors, the people who ascended the Four Stages of Hopi time and life. Their bodies are mud-like, their heads like balls of clay. Doughnut-like eyes, topped by white eagle down. They wear black breechcloths, and brown moccasins.

Masao – this is the Kachina of the God of Death, who is also Fire and Earth in the Underworld. Masao is gray and furry, his face multicolored and gaunt, and he wears a kilt around his shoulders like an old man.

Parrot Kachina – bodies painted red and yellow, white cotton kilts, thin red ears, black and yellow faces, parrot beaks and snow designs on each cheek above long, mysterious geometrical eyes. On top of the head is another parrot beak which dominates all. It projects a mass of colorful feathers and the flaming tailfeathers of the macaw. On the feet, turquoise moccasins, two rings of sleigh bells around the calves, greenery in one hand and a gold rattle in the other. Color is everywhere on the Parrot Kachina.

Talavai – the Dawn Kachina, who, appearing in pairs, tours the village in the early morning and sings to the people. Talavai Kachinas carry hand bells.

Tasap – a "Navajo" Kachina, said to be derived from the Navajo tribe. Tasap Kachina is extremely popular. He has a fringe across the forehead, made of horsehair and dyed red.

Wawarus — the racers, a special kind of Kachina. Each has an attribute and carries a tool or trick. They race men or young boys who will accept their challenge. No ceremonial costumes, no moccasins, no kilt, jewels, greenery or rattles. Some are whippers (or disciplinarians) who sometimes carry scissors in their right hand, sometimes mud or dung or yucca leaves.

The Greasy One — a Whipper, an officer of law and order. He has long ears and is dressed all in black.

Dragon Fly Kachina — he carries corn smut, which he smears on the loser's face.

Skiyataka and Kona — the yellow fox and the chipmunk. Both carry yucca leaves for punishment.

Zuni Warrior Maiden — by legend, she saved the village. Men were out of town when the enemy came, and hair flowing, she called the women to battle and defeated the enemy. Her dark face is crowned with warrior feathers; her red tongue hangs out between sharp teeth. Her dark dress and cape are decorated with two crosses of corn husks. She carries a bow and arrows.

10.
How To Make
Kachina Dolls

Kachina dolls are made in the likeness of the masked figures. They are carved of cottonwood, painted, dressed and feathered just as the dancers are. While the Kachina doll itself is not sacred to the Indian, its religious significance should be remembered; it should not be regarded simply as a toy.

The Kachina doll reflects the Indian's outlook on life, with his gift for the grotesque, his sardonic humor, and his perception of human frailty. The exactness of detail, which conservative Indians have always preferred to keep secret, is less important than the unique artistic and spiritual quality of these dolls.

To carve a conventionalized Kachina doll requires few materials but patience and attention to design and color.

Materials needed:

1. Wood
2. A knife
3. Sandpaper
4. Paint

The Hopi carvers work with cottonwood root, which gives a rough texture to the carving. Since cottonwood roots are difficult to obtain, any piece of straight-grained, soft wood will make a good substitute. Basswood, willow, or poplar — either saplings or branches — are good choices. Green wood is preferable because it whittles easily.

If a lumberyard is your source of wood, white pine, sugar pine or basswood are good choices. Have the wood cut in rectangular sections and then rounded.

A piece of wood about 1-1/2 inches in diameter is a good size to start with. A good quality pocket knife is best for whittling. The blade should be 1-1/2 to 1-1/4 inches long. Sharpen it with a small abrasive stone, using a piece of leather to strap it on. Keep it sharp at all times; you should not be able to see the edge. Sandpaper is needed to sand down knife cuts in the wood.

Two types of dolls are shown here: the flat and the round. The flat slab form is the kind generally given to infants; it is also the earliest type of wooden Kachina — a flat, nonsculptural doll (Figure 9). It involves only a slight amount of carving to indicate the break between the head and shoulder. Nose, mouth, eyes, ears, horns or feathers are added by setting them into mortices (notches or holes cut into the piece of wood to receive the projecting parts that are shaped to fit) and glued.

For body painting, the traditional style is three, five or seven vertical red lines on the body. The shoulders and forearms are indicated alternately in green and yellow. The arms are not carved but indicated by a painted line. The kilt,

legs and feet are not shown. Figure 10 is a more sophisticated version.

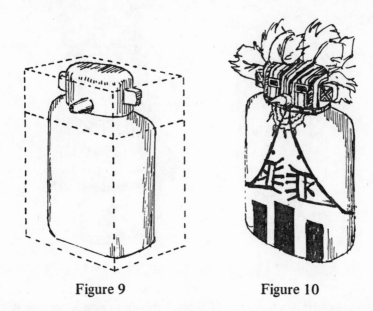

Figure 9 Figure 10

The rounded type of doll is the most familiar today. The type illustrated here is characteristic of the Hopi doll and is the simplest way of whittling Kachina dolls from a round piece of wood (Figure 11). The costume is painted on rather than being dressed in cloth and leather. Arms are carved from the solid block of wood, rather than being movable and attached as the Zuni Kachinas are. Nose, ears and horns are glued on. (Rio Grande carvers only carve the masked head and leave the body a plain cylinder).

The different sections in both the flat doll and the cylindrical one are marked by dotted lines before the carving begins.

For gluing the appendages into place after you have finished carving the basic body structure, use either Elmer's

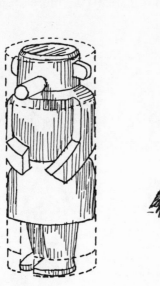

Figure 11

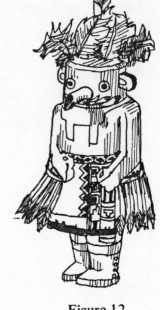

Figure 12

glue or another glue of that type – the main consideration is that it be an adhesive water color paint will adhere to.

Painting the Dolls:

The Indians generally use water-based colors for painting the dolls. Since regular water colors tend to be transparent, a better color is achieved with commercial poster paints.

Use any good quality brush that is small enough to work with easily. Sable brushes are the best, but more expensive. Some of the older Indian carvers use the traditional yucca leaf stems.

There are two methods of painting. In the traditional way, the Indian artist first coated the figure with a light coating of

kaolin, a white clay, and then painted the likeness of the Kachina he wanted to portray. He used earth colors for his painting.

Good poster colors, however, are easier to lay out on bare wood. They should be used in a thick consistency; since they dry rapidly, they are not apt to run over where the colors overlap.

The technique of painting is not as difficult as it might seem. Faces don't have to be painted, and the masks are more or less symbolic or abstract in design. No shading or blending is necessary.

The Indians use nothing to preserve the painted surface, and as a result the water colors are apt to smudge and wear off. But a glossy finish spoils the effect of the doll. There are fixatives, however, which preserve the colors without imparting a shiny surface. Spray-fix is one possibility; this is used by artists to prevent smudging of their drawings when working in pastels or charcoal.

The Eagle Kachina (Figure 12) makes a handsome carved doll. Sources for other models include issues of *Arizona Highways* magazine and crayon drawings of Kachinas, made by a Hopi Indian, in the *1899-1900 Annual Report of the Bureau of American Ethnology,* both of which are available in most libraries.

For adventurous carvers, Tetanya the Wasp offers a more naturalistic pose, brightly decorated with paint (Figure 13). The "antennae" are brightly colored stripes of red, yellow, turquoise and blue, and black at the tip. A black stripe separates each band of color. The top portion of the head is blue, the band below, on which the eyes are painted black, is turquoise; then follows a strip of yellow. The peg-shaped appendage is black in a band of red. The ruff around the neck is green.

The basic body color is red, with the left side of the figure's body decorated with yellow (shoulder decoration and

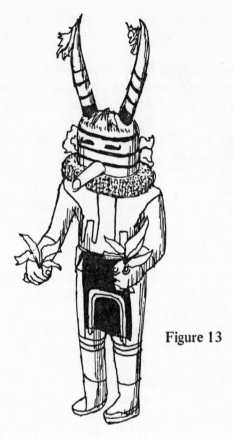

Figure 13

legging); the right shoulder and legging are turquoise. The colors alternate in the stripes above the leggings and in the inside streamer of each shoulder decoration. The waistband is turquoise, the breechcloth black. The Tetanya Kachina holds greenery in hands painted white. The boots are adobe brown with characteristic white soles.

11.
How and Where
To Buy
a Kachina Doll

The Hopis are the only ones who have developed the carving of Kachina dolls into a popular and profitable art form.

Some Hopis who make tihu — Kachinas — are opposed to selling the authentic article (as are the Zunis). They have found subtle escapes to ease their consciences and enjoy a bit of sardonic amusement. The dolls are very carefully carved as usual, but the painted designs — especially on the all-important mask — are often changed, mixed, or elaborated so there is only a semblance of accuracy. The unaware purchaser, of course, is completely satisfied with the "genuine Indian-made" product, so everyone is happy.

The interest of non-Indian scientists in the Kachina doll has had an effect on its development. Large numbers were collected toward the end of the nineteenth century and the

Hopis responded to the law of supply and demand by turning out greater numbers of the dolls. The technical skill of the carvers also increased. By 1900, the form of the doll still retained the characteristic static proportion by which it has become well known, but the doll was carefully painted and in most cases well carved.

Since 1900, other changes have taken place. The conventionalized doll is still carved, but a sophisticated style has developed — many are now also carved in naturalistic poses. The dolls are still carved, painted and feathered with extreme care, but now costumes are often realistic, and the Kachinas are dressed in miniature cloth, leather and metal equipment. The size of the Kachina doll is still usually 10 to 12 inches high.

In some cases, the quality of the doll has suffered. Regular carvers have not been able to meet the increasing demand for tihu, and other Indians, less familiar with the traditional designs, sometimes produced inferior products.

Authentic Hopi-made Kachina dolls of superior quality are expensive. A well-executed doll standing 8 inches tall may sell for $30 or more; elaborate detail work in the carving or costume design may raise the price to as much as $50.

As consumer demands increased, inevitably not only poor-quality products but imitations of the Kachina doll appeared on the market. Some were produced by Hopis themselves, some by other Indians, some by non-Indians in this country and some as far afield as Japan.

The dolls by unskilled Hopi carvers were first to come on the market, followed by a line of "tourist trade" Kachina dolls that were manufactured by Hopis and are familiar in roadside curio shops. These dolls are not representations of a Kachina spirit and can be recognized by the manner in which the base of the doll is carved. Genuine, hand-carved Kachinas have individually carved feet. These particular dolls have a lathe-turned body and a v-shaped notch at the front of the base to indicate the feet. While these figurines may be

manufactured from cottonwood, the authentic article is carved from the cottonwood root.

Even imitations of these pseudo-Kachinas began to appear, carved from pine, fir and balsa. A doll may carry the label "Indian made," but these Indians are often non-Pueblos who may have never seen a Hopi Kachina.

Before World War II, some Kachina dolls were manufactured in Japan and shipped into the Southwest. Made from ceramic materials, molded plastic or plaster, these dolls did not seriously affect sales of the authentic article, but two types of Kachinas manufactured by whites have nearly succeeded in driving the Hopi-made product from the market.

The first of these two types were mass produced. Much of the work was done on power lathes, and the dolls, usually 6 to 8 inches in size, were painted en masse.

The second product was a more serious mockery — the dolls were turned out on lathes as before, but Indians were hired to paint them and the purchaser was assured he was buying "genuine Indian-made" Kachinas.

One other distinct form of the Kachina doll appeared — the cheap souvenir "knick-knack." These are miniature tihu, some as tiny as two inches in height. They are carved, rather than machine made, but often carelessly so and are painted with little concern for accuracy. Some sell for as little as twenty-five cents. The commercialism which inspired the production of these miniature dolls is disturbing to the older, more conservative Hopis who resent having their religious figures made the object of commercialism, even though the depiction is inaccurate.

Very few Kachina dolls on sale in contemporary curio shops today are truly Hopi-made Kachina dolls of traditional design — claims for their authenticity to the contrary. The best assurance of authenticity is to buy directly from the Hopi crafts outlets on the reservation or from reputable Indian art dealers, traders, or museum shops.

12.
Navajo Rugs

Individualistic, colorful, bold — the Navajo rug is a product of the vast land that was its inspiration.

In its original form the rug was a blanket, similar to blankets woven by the Pueblo Indians, from whom the Navajos learned their craft. Later, the Navajo wove "slave blankets," when taken captive by the conquering Spanish. Still later, they produced the classic "chief's blanket," traded far beyond the Southwest. The craft became threatened with extinction, then made a transition from blankets to rugs. Sometimes the Navajo wove with machine-made yarns; more often with wool sheared from the backs of nearby grazing sheep. Sometimes the colors were bright and garish, from a dazzling array of commercial dyes. More often, the rich mellow hues reflected the desert in which the Navajo lived, that beauty-swept barren land which he had made his own.

When the Navajo first learned the art of weaving from the Pueblo Indians in the seventeenth century, his teachers had long been weavers, from the time of the great Cochise culture a thousand years before Christ. These Ancient Ones, pueblo builders, had lived on the windswept upper southwestern plateau. They raised cotton and their weaving was even then a highly developed art.

The Navajo lived farther north, roaming great stretches of uninhabited land. Nomads, plunderers, they lived by their wits and the resources of the land. About the time of the Great Crusades in Europe the Pueblo people, beset by raiding Navajo, drought and disease, moved southward to the upper drainage of the Rio Grande River, where their descendants, the modern Pueblo Indians, now live.

The Navajos remained in the plateau country to the north until the sixteenth and seventeenth centuries, when they again were on the move into Pueblo country. At the same time, Europeans were moving into the Southwest from Mexico. While there were probably no Navajo in the area when Coronado came seeking gold in 1540, it is almost a certainty that within a hundred years the descendants of the Conquistadors were intermingling with the roaming bands of Navajo.

The Pueblo Indians and, in turn, the Navajo learned the use of wool for weaving from the Spanish who brought sheep with them when they first came. Coronado brought with him 5,000 scrawny, long-legged sheep called "churros" which were to have a profound effect on the lives of the Indians in New Mexico and northern Arizona. This lowly beast, of the kind used by Spanish peasants, needed little care. His wool, which was greaseless and often brown in color, was long and straight, and needed little preparation for weaving.

The Pueblos still raised cotton and wove with it, but now they had also acquired wool. It was a fairly peaceful time, interrupted only sporadically by Navajo raiding parties who

broke into the pueblos and took what they could use. The livestock the Navajo stole included the "churro."

More and more the Navajo way of life was being curtailed by the settlement of America. So the Navajo turned to a new way of life, becoming a pastoral nomad — thanks to the horses and sheep he took from his would-be conquerors. He increased his flocks, he began to learn the art of weaving from his Pueblo captives, and the natural consequence was the widespread production of textiles throughout what was to become his reservation.

Copying techniques from the Pueblo Indians about 1700, the Navajos first wove dresses and blankets similar to those of the Pueblos, using their own wool and plant dyes. Fragments of early blankets have been found; the designs in these fragments is a plain stripe pattern, an adaptation of Pueblo work.

Between 1800 and 1850 Navajos captured by the Spanish were put to work weaving blankets which could be worn. These blankets have come to be known as "slave blankets." Very few of them are still in existence. The Navajos also took slaves — the Spanish. There is speculation that some of these "slave blankets" may have been woven by their Spanish captives.

All of the "slave blankets" show strong Mexican influences. However, Mexican blankets were woven on a horizontal loom and the Navajo blankets were, and still are, woven on an upright loom. The Mexican weaver used a shuttle to place the weft threads from one edge to the other. Sometimes pattern colors were inserted, but otherwise the weft threads went all the way across the warp threads. The Navajo wove in the same direction, across the blanket from edge to edge; but using the upright loom the slave weaver would weave as far as she could comfortably reach, then move over to do another section. Each place she stopped produced diagonal breaks in the weaving. These are known as

lazy lines. Lazy lines are not the exclusive province of slave blankets, however. Some modern weavers are also guilty of lazy-line weaving.

Skill and productivity of Navajo weaving increased, and by 1850 the Navajos had developed a distinctive type of blanket known as a "chief" (Figure 14). With this blanket the

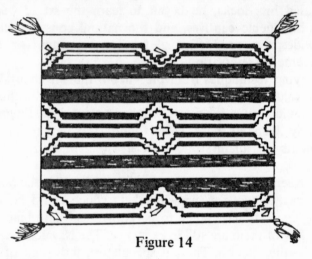

Figure 14

Navajos became exporters. Superior in quality (and expensive), chief blankets became prestige items. Their popularity undoubtedly contributed to the development and growing recognition of Navajo weaving. But, most important, the chief blanket set the pattern for the Navajo textiles becoming an export item, an economically important factor to these nomad weavers.

These blankets were woven by Navajos for sale or trade to other Indians throughout their trading area. The Navajos themselves had no "chiefs" — chiefs of other tribes were the only ones who could afford to buy them. They were also given as gifts to Army commanders. These were fine blankets, expertly woven and traded far beyond the Southwest. The

design, of classical simplicity and boldly executed, evolved from the simple striped style.

The chief blanket marks the beginning of a period in Navajo weaving designated as the Classic Period, from about 1850-1870. The development of the chief blanket continued during these years and also a new type of blanket, the Bayeta blanket, began to be woven.

Bayeta refers to a type of wool cloth called Bayeta cloth which was manufactured in Manchester, England. It was similar to loosely woven flannel. The cloth was shipped to Spain, then to Mexico, and eventually found its way into the Southwest. Bayeta cloth was usually red in color, dyed with the cochineal bug, and it appealed to the Navajos, who loved red and who at this time had no way to make a red dye of their own. The Bayeta cloth was unraveled and spun into yarn, and then woven into the Navajo blankets. The story is widely circulated that the Navajo wove red cloth from Spanish uniforms. But considering the Navajo fear of the dead, it seems unlikely. As Gilbert Maxwell suggests, the last thing a chinde-fearing Navajo would do would be to touch a dead body, let alone strip it. Chinde, in the Navajo language, is a ghost or spirit of the deceased, and much to be dreaded.

When the Navajos were imprisoned at Fort Sumner, New Mexico, from 1864 to 1868, weavers were exposed to new ideas and materials. Here they were given machine-made cloth — velveteen and cotton for the women to be made into copies of the pioneer women's clothes at the fort — and unbleached muslin for trousers for the men. After their release in 1868 they went back to their reservation, but the use of velveteen blouses for both men and women, and full skirts for women, persist.

Around 1880, the quality of classic Navajo weaving suffered a sharp decline. Commercially made, brightly colored four-ply yarns found their way into the reservation and the weavers went on a color jag. These "Germantown

yarns," named after the textile city of Germantown, Pennsylvania, were used from 1880 to 1910. At the same time, aniline dyes became a standard item on trader's shelves. Also, manufactured fabrics continued to come into the reservation, and then ready-made clothing and Pendleton blankets.

It was no longer a necessity to weave blankets for wear and for warmth. Up to this point, Navajo weaving had centered around the making of blankets that were to keep the Navajos warm, or to trade with other Indians.

Navajo weaving was in danger of becoming extinct and was revived by traders, who probably saved the craft. In the transition, the Navajo rug was created. About 1890, the Navajos began to weave rugs to sell, instead of the traditional blankets to trade.

More and more people had been tossing their Navajo blankets on the floor, using them for rugs. The traders had caught on quickly. They insisted that the Navajo weaving style change to a product that could be used on the floor. They helped the Navajos develop a heavier type of weaving with borders instead of stripes. With this change in weight and use came changes in pattern and color. Large geometric designs with borders and a wide variety of commercial dyes replaced the earlier simple striped patterns in limited colors. The traders were right in thinking that these would appeal to the new non-Indian market.

These first rugs were known as "pound blankets." They were not, for the most part, well made. Traders paid for them by the pound, and the Navajo weavers were quick to catch on. Often the wool was not washed to remove the dirt and grease. In fact, weavers pounded sand into the yarn to make the rug weigh more. The spinning, weaving and dyeing were often carelessly done.

But the traders demanded high quality and encouraged the use of subtle colors from vegetal dyes, and gradually

throughout the reservation the relationship between trader and weaver produced rugs that reflected the tastes of both and were characteristic of the region from which they came. These rugs can be identified by the area in which they are woven and each has a distinctive style, pattern and color of its own.

Gallup, New Mexico, is the largest trading center of Navajoland and rugs from all areas of the Navajo reservation can be bought here. There are also trading centers clustered in the main weaving centers themselves.

The main weaving areas discussed here center around the borders of New Mexico, Arizona and Utah, with the farthest east in Tuba City, Arizona. In most cases the rugs are named for the area in which they are woven.

The Gallup Throw Rug

Gallup, New Mexico, is the gateway to the Navajo Indian Reservation, which lies north and west of the town. It is an Indian trading center and rugs are brought into Gallup from all corners of the reservation. Gallup originally was a railroad town, set up because of the coal reserves nearby, and there is still some mining in the area. Zuni, Hopi and Acoma Indians also trade here and it is justifiably called "the Indian capital of the world." The black-haired women in long, full calico or velvet skirts, draped with silver jewelry, are Navajos.

Weavers in the Gallup area make a rug known as a "throw." Unlike rugs in other parts of the reservation, Gallup throw rugs are woven with cotton warp. Their size is small, usually only 18 x 35 inches. The throw rug has a fringe two to three inches long, made by leaving the warp loose at the ends and tying knots to the last welt.

These rugs are lightweight and are usually bought for decorative purposes, as table top and pillow covers.

The Gallup "throw" has no distinctive pattern, design or color. Occasionally corn stalk figures and Yeis are woven into these rugs.

Gallup throws can usually be bought for under $10.

The Ganado Rug

The rug perhaps most familiar as a "Navajo rug" is the Ganado rug (Figure 15) — named for the area in Arizona in which it is woven. These are red-black-white-gray rugs, with bold, simple designs.

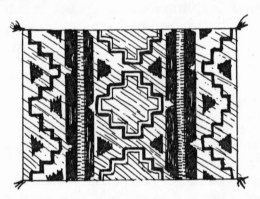

Figure 15

Their fame and popularity is well deserved. They are beautiful, distinctive rugs. An enterprising trader, J. Lorenzo Hubbell, along with the Fred Harvey Company, is credited with the fabulously successful merchandising of this rug. The Fred Harvey Company bought thousands of dollars worth of red-black-white-gray rugs from the Hubbell trading post at Ganado and sold them to tourists up and down the Santa Fe Railroad line at the famed Harvey Houses.

The Ganado is not a vegetal dye rug. The blacks, the

whites and the grays are the natural wool colors. Two aniline
dyes are used: red and black. The black is used to intensify
the black of the natural wool, which has a reddish-brown cast
in its natural stage.

The "typical" Ganado has a deep red background with
diamonds or crosses as favorite design motifs. The largest
Navajo rug ever made — 24 x 36 feet — came from this area
in the late 1920s.

Wide Ruins Area

West of Gallup is the Wide Ruins area, the main vegetal
dye region of the Navajo Reservation. From this area come
the best examples of vegetal dye techniques, the most
important and far-reaching modern innovation in Navajo
textile art (Figure 16).

The real development of vegetal dyes began in 1930 with
the work of a Navajo woman in Wingate, Arizona, Nonabah
G. Bryan. She was successful in creating 84 different dyes
with plants gathered from all over the Navajo Reservation. A

Figure 16

couple named Sally and Bill Lippincott bought the Wide Ruins Trading Post in 1938 and encouraged weavers to increase the quality of their weaving, using vegetal dyes and handspun wool.

Nonabah Bryan's work is specially significant in light of the fact that at the turn of the century only a few vegetal dyes were being used by the Wide Ruins weavers. Writers of the period describe native dyes and talk about yellows made from rabbit bush, blacks from sumac, piñon pitch and ochre (a yellow or reddish clay which contains iron); and red which was obtained from the root of mountain mahogany. The black of the wool was often intensified by the use of black dyes, to offset the wool's natural reddish-brown cast.

The Navajos were using a fourth color — light green — and probably achieved this by mixing yellow with indigo, a blue dye obtained from certain plants. This apparently completed their range of colors.

There was an experiment in the 1920s with chemical dyes which ultimately failed, but which was an attempt to reproduce the soft but full and mellow colors of the southwestern environment and widen the range of colors available to the Navajo weavers. Mary Cabot Wheelright, Navajo sponsor and supporter, and L.H. McSparron, a Navajo trader, obtained the cooperation of the Du Pont Chemical Company and some dyes were mixed and used. The project was finally abandoned, because the Du Pont dyes had to be fixed with acids, a complicated and potentially dangerous procedure which the Navajos were not trained to handle.

It is possible, however, that the experiment stimulated the ingenuity and imagination of the Navajos, and Nonabah Bryan in particular.

She was a teacher of weaving in Wingate, Arizona. With her small daughter, Mrs. Bryan "tramped over every hill in Navajoland" (as her small daughter recalls) collecting plant materials. From them, she prepared recipes for the 84 dyes

she is credited with creating. These she collected in an extraordinary booklet.

As an example, from the cliff rose she extracted a dye that turned wool a golden hue. In her booklet she instructs:

2 lbs. of fresh cliff roses, twigs and leaves
1/4 cup raw alum
1 lb. of yarn

Boil the twigs and leaves in 5 gallons of water for 2 hours. Steam. Add raw alum to the dye water. Stir and let boil 10 minutes. Add the wet yarn and strain again. Boil for 2 hours. Allow to remain in the dye bath overnight. Rinse.

From the prickly pear cactus, Mrs. Bryan obtained rose and pink. From sagebrush, a greenish yellow.

The designs in the vegetal dye rugs are bands with geometric figures. The main center of Wide Ruins, west of Gallup, is in the mountains south of the Chinle Valley. Rugs are sold at trading posts with colorful names — Klagetoh (Cloudy Water), Pine Springs, Burnt Water, Wide Ruins.

These posts not only handle the vegetal dye rugs but the tourist or collector may also find rugs from the neighboring Ganado area.

The Yei Blanket

The Yei Blanket (Figure 17) is made in the Shiprock area, in northwestern New Mexico. Yei figures are the divinities depicted in sand paintings, but this type has no sacred significance.

The Yei Blanket was commercially developed in the early 1900s by Will Evans, a trader-owner of the Shiprock Trading Company. The Yei is a religious figure taken from the highly

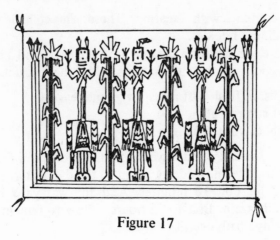

Figure 17

stylized sand paintings and is their actual representation of these supernatural beings. The Yei figure is depicted in healing rites. Medicine men make these designs.

Even though the blanket itself has no sacred significance, the fact that representatives of the sacred figures are woven in at first caused Will Evans' attempt to develop this blanket to be met with violent opposition from the older Navajos. But because these blankets were never a part of the ceremonials, permission was finally given for the blankets to be woven.

Yei Blankets are not to be confused with the so-called ceremonial or prayer rugs. The white man's commercial mind invented the latter; there is, in fact, no prayer rug used in Navajo ceremonials. Don't be mislead by a sales pitch.

The actual Yei figure is colorful; many different colors are used. The background is usually white, setting off the brightly costumed stylized figures. The typical Yei blanket also has a stylized rainbow figure woven down its two sides and across the bottom.

Yei blankets are relatively small and are usually hung on the wall like a fine tapestry.

The Two Gray Hills Rug

The Two Gray Hills rug (Figure 18) takes its name from an area between Shiprock and Gallup. These rugs are woven in natural colors and geometrical designs. Known as the aristocrat of Navajo rugs, the development of this rug is credited to two traders, George Bloomfield and Ed Davies, whose encouragement increased the quality of the workmanship in the rug and enhanced its color and design. The colors the Navajo in this area used in their rugs are those often associated with elegance — blacks, whites, grays and shades of brown. The gray is not dyed; black and white wool is carded together. For tan, brown and white are blended.

Geometric designs are the basic designs.

Teec Nos Pos Rug

This rug is named for an area west of Shiprock near where four states — Arizona, New Mexico, Colorado and Utah — meet. Teec Nos Pos means "circle of cottonwood trees."

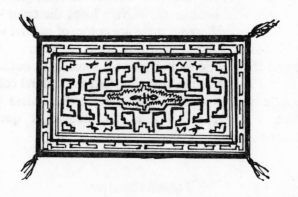

Figure 18

The rug of this area is complex in color and design. It looks good against a stark white background. It contains a dazzling array of rainbow colors woven with commercial yarns. The designs in the rugs are outlined by colors — one and sometimes more — pinks, oranges, blacks, reds, purples, whites and grays. The geometric patterns — diamonds, bars, stripes, squares — are filled in with color. In terms of what has come to be thought of as characteristically "Navajo" in feeling, the Teec Nos Pos could be called "non-Indian." The Teec Nos Pos is a favorite of collectors.

The size of these rugs varies, from relatively small wall hangings to a larger 10 x 18 feet.

Red Mesa Rug

If you're in the Teec Nos Pos area, you might want to go on to the Utah border and visit a group of trading posts called Red Mesa, Sweetwater, and Mexican Water. The weavers in this area don't use the gaudy colors of the Teec Nos Pos Navajo — the yarn is usually handspun, with a coarse finish but of good quality. These blankets are colorful and geometric in design, with the traditional reds, grays, blacks and whites. Red because the Navajo loves the color — grays, blacks and whites because these are colors of natural wool.

There has been an exchange of ideas between neighboring areas and the Red Mesa rug weavers sometimes outline their rugs in the Teec Nos Pos tradition. But the natural colors and occasional vegetable dyes used by the Red Mesa weavers produce a softer effect than the neon-light quality of commercial dyes.

Lukachukai Area

West of the Lukachukai Mountains are three trading posts

that handle a rug characteristic of the area. The posts have colorful, geographical names – "Upper Greasewood," "Round Rock," and "Lukachukai." The rugs are called Lukachukai.

The Yei figure from the Navajo sandpainting appears in these rugs, but here the design is larger, the colors bolder, the quality coarser, than in the Shiprock-Red Mesa rug across the mountains.

The Lukachukai rugs, unlike the more delicate Shiprock tapestries, are heavy, handspun and suitable for the floor. Some are as large as 8 x 10.

Sandpainting Rugs

Unlike the Yei figures, which represent religious figures but are not considered sacred, there are also Sandpainting rugs. These rugs are woven copies of actual sandpaintings. The weavers who make these rugs do so in direct opposition to their religious beliefs. The Navajo believe that the one who reproduces a sandpainting in any other way than dry sand will go blind. The first Navajo to break this taboo was Hosteen Klah, a medicine man in the Two Gray Hills area. He was persuaded by Mary Cabot Wheelright, a lifelong friend of the Indians, to weave several sandpainting rugs in the early 1920's. Miss Wheelright was concerned with the welfare of the Indians and with preserving their culture and religious ceremonies. Since by 1933 the Indian culture was nearly extinct and the Indians were thought to be a disappearing people, her fears were not without foundation. With the help of Hosteen Klah, many color drawings of sandpaintings were made which later served as rug patterns.

Authentic reproductions of sandpainting rugs are woven in the Two Gray Hills and Shiprock areas. They are more expensive since it takes a very skillful weaver to copy a sandpainting.

The sandpainting rug is square — usually 5 x 5. The colors are varied; the yarns are either commercial or handspun.

Crystal Rug

The trading post of Crystal is south and west of Two Gray Hills, beyond Washington Pass. The Crystal rug is another example of a rug encouraged and developed by a trader, one J. B. Moore, who ran a trading post in this area from 1896 to 1911. He had an eye on the eastern market and the tastes of non-Indian buyers in mind. Establishing a mail order business, he published a handsome catalog in 1911 which carried the first color plates of Navajo rugs.

Many of the ideas for designs for these rugs were Moore's. But the Navajos, being good businessmen, were interested in selling their products, and the result was a distinctive, marketable rug. Borders, crosses, diamonds, hook figures, and a lavish use of red characterized the Crystal rugs of this period. These are now collectors items; the Crystal Rug woven today, following a period of decline, is equally distinctive. Vegetal dyes now predominate — subtle earth colors — and the design is simple and contemporary in feeling.

The rugs are well made, with handspun yarns. Crystal rugs vary in size from 3 x 5 to 8 x 10.

Chinle Area Rugs

The Indians call it "at the mouth of the Canyon" — picturesque trading posts dot the entrance to the long low valley of Chinle, in northeastern Arizona.

For sale at the Thunderbird Trading Post, or Naglivis, two of several outlets for the Chinle weavers, are rugs reminiscent of the old borderless blankets. A distinctive khaki color is

produced from vegetal dyes and used by local weavers, in addition to other pastel hues. Bands with saw-like notches, simple stripes forming the main themes mark Chinle rugs — characterized by coarser weaving than the Wide Area rug.

Keams Canyon – Piñon Area Rugs

In the heart of the Navajo country, the geography is characterized by rolling hills and mesas. West of Ganado, the Ganado rug is duplicated by weavers who, nevertheless, stamp their own individuality on their products.

Traveling west from Ganado, the tourist or collector will come to the Keams Canyon Trading Post, where he will find Ganado-type rugs with deep red backgrounds and bold geometric patterns. Navajos in the area also trade at the trading posts of Piñon, Indian Wells and Bita Hochee.

Storm Pattern Rugs

The designs of Storm Pattern rugs (Figure 19), made near Tuba City, are symbolic. Stepped lines radiate from the center of the rug and represent lightning. Blocks in each of the four corners of the rug represent the four sacred mountains of the Navajos.

The Navajos marked the boundaries of their land by these four mountains. In these mountains, they believed, dwelt the forces that held the world together. In the east was Mount Blanc, a majestic snow-covered peak in southern Colorado, in the Sangre de Christo range, the southern spur of the Rockies. To the west was the tallest of the San Francisco peaks in Arizona, Doko'o'slid. To the north, a mountain in the La Plata range of Colorado, Mt. Hesperus, called Dibentsaa by the Navajos. And in the south, the mountain known as Mount Taylor in New Mexico, called 'Tso-dzil by the Navajos.

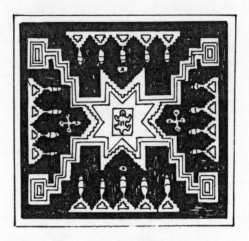

Figure 19

The Storm Pattern rug has been made since 1900 in the west reservation area. The familiar red-black-gray-white color combination is common in Storm Pattern rugs, as well as an elegant gray, black and white. Some vegetal dyes have been used by the weavers in this area but on the whole the traditional Storm Pattern rugs are most successful.

Storm Pattern rugs may be seen and purchased in Cameron, Tuba City, at Kerley's Trading Post, the Copper Mine Trading Post and others in this area of the Navajo reservation.

Coal Mine Mesa Area

A rug is being woven in the Coal Mine Mesa area which marks a departure from the ancient techniques used by Indian weavers and is an innovation in the craft. Ned

Hatachli, a Navajo active in Indian affairs, has designed a raised outline double-weave rug. It is a separate and distinct "x" design and method of weaving. These rugs are being produced at Coal Mine Mesa and in Tuba City in Arizona.

13.
How To Weave
Navajo Rugs

Navajo rugs are woven on a vertical loom which may have been invented in the Southwest. There have been no modern innovations in this loom, and some of the looms used by the Navajos have been used for generations.

The loom's basic construction consists of two horizontal warp bars — an upper and lower (Figure 20). (The warp are the threads that run lengthwise; the weft are the threads woven across the fixed threads of the warp — the part of the rug you see.) The upper warp bar is tied to a tension bar (a. and b.). The tension bar is suspended from the frame by a rope which can be pulled to tighten the warp or loosened to lower the working edge of the rug.

The first yarn to be placed on the loom is the warp thread. This is strung between the upper and lower warp bars. The down thread crosses behind one or the other of the bars, the

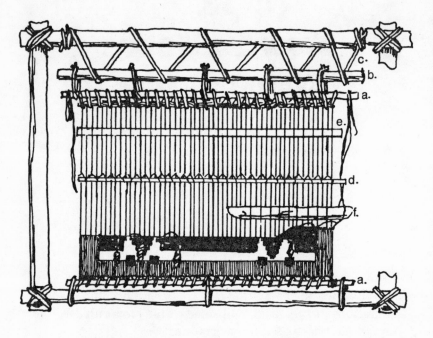

a. horizontal warp bars d. heddle rod

b. tension bar e. shed rod

c. rope f. batten

Figure 20

up thread runs opposite. In this way, the closely spaced threads form a "figure 8," crossing in the middle (c).

A "heddle rod" (d.) is attached to alternate warps by loom loops so it can be moved up and down.

A rod called a "shed rod" (e.) is inserted in front of these warps that are attached to the heddle rod. It is used to push them back behind the others.

A sawed strip of wood called a "batten," shaped like a narrow paddle 18-24 inches long, separates the sets of warp for insertion of the weft (f).

Strong border cords are woven into place first. These serve primarily to keep the warp threads separated and in place.

Basic Steps in Weaving

1. After setting up the loom, first pull the heddle rod toward you. The alternate sets of warp attached to it move forward and separate from the others (Figure 21).
2. Insert the batten into the space you have made.
3. Turn the batten on its broad side. This will widen the space between the sets of warp. Pass the weft through this space (Figure 22).
4. Turn the batten back on edge. Then take a comb (or use the batten) and push the weft down into place (Figure 23).
5. Remove the batten.
6. Pull the shed rod down. This pushes one set of warp behind the other and crosses them over the new weft strand (Figure 24).
7. Insert the batten again between the sets of warp (Figure 25), turn it on its broad side, pass the weft between the separated sets of warp; push down the weft with batten or comb.

8. Remove the batten, push up the shed rod, and repeat the entire procedure (Figure 26).

For a simple over-and-under tapestry-weave rug, two heddle rods are used. One is tied to alternating warp threads and the other — a loose untied heddle — is inserted between the other warp threads. The latter heddle is used to pull forward the even warp threads. All the even warp threads are brought forward by pulling this one heddle, and are separated from the odd-numbered ones.

Weaving tools:

1. Wooden battens
2. Combs and pins
3. Sacking needles

The battens open the shed and pack the wefts into place between the warps. Pins and combs push the wefts into place between the warps. The final weft threads are inserted with sacking needles.

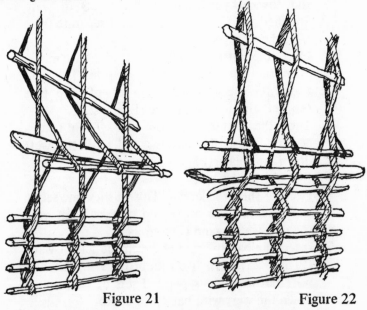

Figure 21 Figure 22

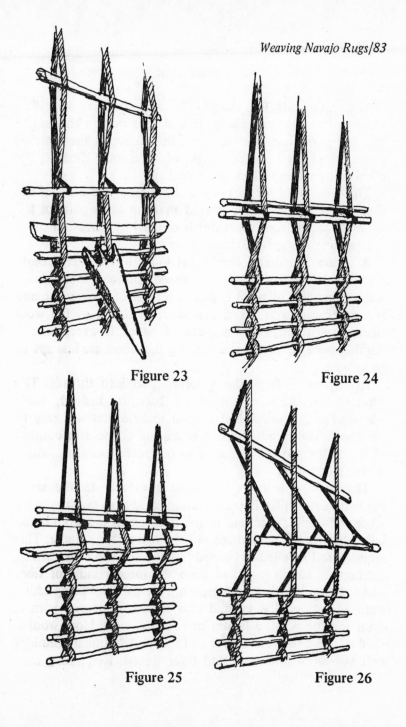

Figure 23

Figure 24

Figure 25

Figure 26

Materials Used

The yarn used for weaving Navajo rugs may be either handspun or machine made. If a Navajo woman chooses to buy her yarn from a store, then her source is the same as yours. Wool for handspun yarn, which is more durable, she obtains from sheep which graze nearby.

The wool used for weaving is shorn from the *back* of the sheep, where it is longer-fibered than on other parts of the animal. Once shorn, the wool is cleaned of burrs and other debris, then washed and dried in the sun.

A carder is a metal comb that looks like a curry comb. With a pair of them the wool is raked into long, loose, fluffy rolls. A handful of wool is placed on one of the carders, and the other carder is raked across it. In this way, the wool fibers are untangled. Hand-carded wool is exceptionally durable because with hand carding the fibers are less apt to be broken.

After the carding, the wool is spun into threads. The spinning wheel is not used by Navajos. Instead, these nomadic people developed a hand spindle that was easy to transport. The spindle looks like a small ski pole. It consists of a wooden rod with a disc of wood, pottery or stone which acts as a flywheel.

The hand spindle is far more adaptable to the semi-nomadic desert life that the Navajos lead than the stationary wheel. The spindle is held in the right hand, the wool in the left. The wool is wound around the top of the spindle. This wooden rod is rolled or twirled to twist and wind the yarn. A continuous strand is pulled from the loose bundle of fiber and is twisted on the spindle, more carded wool being added until all the wool is twisted into thread. A heavier yarn is spun for the warp, a lighter one for the weft. More wool is used to make the yarn coarse and heavy. Additional spinnings pull the wool into finer and finer thread. Respinning may

also be done to make yarn hard and smooth. Black and white wool may be blended to make gray.

Navajo handspun yarn can be identified by its left-hand twist. Pueblo yarn and machine-spun yarn have a characteristic right-hand twist.

Dyeing the Yarn

If the yarn is to be dyed, this process is done after the spinning. Vegetal dyes used by the Navajos utilize a wide variety of plants, berries, bark, fruit, roots and flowers.

Aniline is a colorless, oily liquid derivative of benzene, and is used in making the commercial aniline dyes. These are also utilized by Navajo weavers.

Designs of Indian Rugs

The early designs in Navajo weaving were copied from the Pueblo blankets; their first blankets were similar. (The plain stripe pattern is characteristic of this period.) These early blankets had simple designs and somber colors.

As Navajo weaving developed, geometric designs became characteristic — not because they are particularly Indian but because of the limitation placed on design by the vertical construction of the loom.

Some patterns have acquired names through common usage, although they are without significance. The sand-painting rug is in a sense an exception since the figures woven in it represent the Yei deities of the paintings made in sand. However, weavers use design elements adapted from the sandpainting and the rugs are therefore more design than symbol. Gilbert Maxwell believes symbolism is behind the Storm Pattern rug, with the jagged lines symbols of lightning

and the four rectangles in the four corners of the rug representing the four sacred mountains. If this is true, the Storm Pattern rug would resemble the symbolism used by the Pueblos in decorating their pottery. Whiteford, however, in *Indian Arts* described the rugs simply as having basic patterns of zigzags and rectangles.

How to Buy a Navajo Rug

Navajo rugs are one of a kind. If a rug appeals to you, if the craftmanship is good and the price is right, buy it. You won't find exactly the same rug again.

Quality in Navajo rugs varies, both in the weave and in color uniformity. Check to see that the tightness of the weave is the same throughout the rug. Examine the width of the design at either end. It should be the same. The horizontal and vertical lines should be straight and uniform in width. The warp threads should not show. No handmade rug will be perfect; part of its charm would be lost if it were. But good craftsmen produce a consistency of quality that marks the difference between superior quality and sloppy work.

The colors in a rug reflect the care that the weaver has taken. If a single hue has marked variations, the weaver may have been careless in dyeing her yarn. Sometimes more than one batch has to be dyed for a rug, although the weaver tries to dye what will be sufficient for weaving the rug. White should also be checked. If the wool has not been properly cleaned, the white will be streaked with black. Also, be sure the white yarn is not full of chalk to make it look whiter.

14.
Pottery

Pottery is an ancient craft of the southwestern Indians. Pottery making perpetuates a 1,500-year tradition — the earliest mud vessels found in a cave in northeastern Arizona were tree-ring dated in the fifth century. These pots and jugs belonged to the "Basketmakers," who were early ancestors of the modern Pueblo Indians. Between the fifth and eighth centuries, these early farmers first learned to make pottery.

Their basketry dates from about 100 A.D. Pottery making followed basket making, and clay — used to strengthen a basket as a cooking utensil — led to the discovery of the clay utensil itself. Fragments of thick mud dishes, molded in baskets, have been found in Basketmaker caves. These pots had not been fired and were not pottery in the true sense. It is conjectural whether the Basketmakers learned to fire themselves or whether they learned from others that clay

could be made moisture-proof by the process of firing it. Archeologists have found remains of mud pots turned to semi-stone in burned out dwellings and speculate that the change would have been observed and attempts at deliberate firing made. However, there were, at this time, other cultures flourishing which had developed pottery to a high art, both in southern Mexico and Central America. Closer to home, the Hohokam — another prehistoric culture — were making pottery in the southern deserts and valleys of the Southwest. Hohokam pottery predates Basketmaker remains.

The indications are that Basketmaker pottery ultimately became a combination of local efforts and imported pottery. In form it reflected basket and gourd shapes, those forms already existing in basketry. Its decoration progressed from an imitation of the basket maker's art to styles suggested by elements of the pottery itself.

In physical appearance, the pottery was a dirty gray, the color of the clay somewhat smudged by the firing process. Granules of coarse sand, the usual tempering material, flecked its surface.

In method, the Basketmaker potter used methods that were similar throughout the world in cultures where the potter's wheel was unknown. The process is still carried on by Pueblo potters. A lump of clay was pressed into a mold — a basket or a pottery saucer. The walls were built upward by adding rings of soft clay, each ring carefully molded by finger pressure to the edge of the vessel. The joint was then scraped smooth with a potsherd or gourd shell and the next ring was added. To shape the vessel, the individual rings were enlarged or contracted as the vessel was constructed. A final smoothing was done with moistened grass, which left striations on the surface. Polishing was not customary, as it is today, nor was slipping — the practice of adding a coat of clay which serves as a background for decoration. When it was thoroughly dry the vessel was painted, then fired.

Firing methods of the Basketmakers were probably similar to those used in the Southwest today. With some variations, the basic steps would have been simple. A platform of firewood was first laid, perhaps in a shallow hole. Loose stones were placed on the platform in order to prevent direct contact of the pots with embers. Then the pots were placed, bottoms up, on this base. A dome of firewood would be laid around and over the pile. In order to prevent smudging, fragments of old pottery would be placed between the pots being fired and the wood. The pyre would be lighted at several places and then allowed to burn itself out, a process probably taking only a few hours. Thus, by this method, pottery was fired and made durable.

Decoration of early southwestern pottery evolved slowly. The first pots were undecorated. Then potters began to apply a mineral paint after firing. Red ochre was a common choice, which archaeologists call fugitive red because of its tendency to rub off. Mineral paints were used in painting pictographs and woven articles of clothing, and it was natural that potters would attempt to use the same technique in pottery painting.

Later pottery shows evidence of the discovery of a more durable type of paint – a paint that would fuse with the surface of the pot in the heat of the firing. This is a thin, rather dull black.

The use of two different formulas for this black paint has existed since prehistoric times – on a broadly north-and-south regional basis – and still exists. In the eastern or Rio Grande pueblos, black paint is obtained by boiling certain green plants to extract their sap. This vegetal paint carbonizes in the heat of firing and a film of silica from the clay hardens it.

Among the Pueblo potters in the west – Hopi and Zuni – a ferruginous clay is added to the boiled sap, giving a brownish tinge to the black paint.

The decorative styles of pottery began with a transfer of designs from one medium to another – from basketry to

pottery. However, the demands of the technique and material of the basket maker imposed certain limitations.

The basket maker patiently built both her vessel and her pattern, stitch by stitch. She thought in terms of lines — either plain lines or simple linear figures. Her usual approach was to start three or four lines, or perhaps a series of lines, when she began the basket. These she flared outward, often in zigzag steps, until both the basket and her design were complete.

Early pottery designs showed the unmistakable influence of the limitations of the weaver's medium — the potters painted the same tight little patterns they had been accustomed to weaving into their basketry. But with time and experience in the more pliable material, the designs achieved more fluidity.

The pottery painter, with her yucca brush, could create any form she desired. She could make lines; she could also go back and embellish them. If a pair of lines gave a sparse effect, why not create a design to fill the void between them? Lines, then, instead of being the design itself, often became the framework within which a decorative pattern was fitted.

There were also adventurous artists; some potters decorated their pottery with human and animal figures and strange blends of the two. But this naturalism did not survive among the early Basketmakers. It did revive again several centuries later, however, and it appears today, along with the geometric style, in that unexpected blend which is Pueblo ceramic decoration.

In addition to the change from structural textile design to freehand pottery painting, there occurred a change in the focal point of the design itself. The bottom center of the basket is the beginning of coiled basketry and it was usually the hub of the pattern as well. Early pottery painters began their decorations in a similar way but this is a more awkward method than painting from the rim of the pot downward to

the bottom center. Structurally, the pot has no center but it definitely has a rim, the rim dominating to such a degree that no design is thoroughly satisfying that in some way does not fit harmonously within that circular area. So it was natural, if not esthetically inevitable, that the rim would replace the center as the point of departure of the decorative scheme.

The practice of drawing short bands from rim to center became one of drawing longer bands from rim to rim across the center. Gradually, a further change involved the device of creating decorative zones pendant from the rim and extending toward the center, but not meeting there.

These ceramic developments probably covered a period of some five hundred years. While the tradition has been continually renewed, it remains basically unbroken.

Painting the Pottery

The yucca leaf was commonly used as a paint brush in the Southwest. Indians of the Rio Grande pueblos cut a piece from a yucca — one of the heaviest leaves. They trimmed the blade of the leaf back to the stem so that what was left was a narrow, three-sided little stick like the quill of a feather. Then the Indian painter chewed the thicker end so that bits of the hard, stiff part came away from the long fibers.

The Indians always painted the designs on their pottery freehand; they made no preliminary sketches (Figure 27). The symbols that they used were symbols from their way of life that were meaningful. In general they didn't have time to decorate the pots they used for cooking and carrying water, but those that they used for trade, for presents or for ceremonials were decorated. The religious pots had special significance and the symbols were traditional. Other pottery was decorated to look pretty. The water snake was a common symbol — it was painted to bring luck and happi-

Figure 27

ness. Flowers were also a symbol of happiness and luck. In a double-spouted wedding jar, squares might stand for the bride's house. The designs in southwestern pottery are the most symbolic of North American designs. Lines which circle the pottery are never closed; this is the exit trail of life or being. When animals are painted, the lifeline is shown. The heart of the animal is drawn and then a line from the mouth down to the center of the heart. There's always a little space left on either side of the line as the entrance trail for the breath of life.

These were symbols that were significant to a people living in a semiarid desert region, whose existence depended on water, whose religious ceremonies were designed to bring rain, whose lives depended upon the crops they could raise with that rain.

Frogs, tadpoles and dragonflies are common rain symbols found especially on Zuni pottery.

Colors are a matter of choice of the artist and of colors available. Colors for the Indian sometimes stood for color in his environment – the yellow of the sun and of corn; the blue-green of sky and water. Sometimes they stood for moral characteristics – red for courage. Most of the colors – yellows, dull reds, and browns – were colored earths. Black was iron or manganese. The minerals were powdered in stone mortars and mixed with water.

Firing the Pottery

The Indians of the Southwest are the only Indians still making their pottery in the traditional way. Some of the

Figure 28

Figure 29

finest pottery in the world is made and sold in the villages of this area.

Firing in the traditional way takes great skill and experience. It is not the most perfect way of firing pottery, but because of variable factors, experimentation is possible and new styles are developed. It's a living, changing art even though its methods are traditional (Figures 28, 29, 30).

Alice Marriott, in her excellent book *Maria, the Potter of San Ildefonso,* describes a method of firing.

Make a hole in the ground.

Put down cedar bark, then a layer of broken pots and whatever scraps of metal can be found on the dump.

Have a big pile of cedar wood, chopped and ready, beside the fireplace in the house.

Figure 30

On a still day:

Put one layer of pots down on the firebed of broken pottery and scrap metal.

Build a shelter over them with the first of the cedar sticks.

Put the painted pottery down on the firewood; put another rack of cedar over them because these are less likely to be smoked if they are in the middle of the pile.

Then a top layer of more pottery, covered with more cedar.

(Traditionally, the Indian woman takes a little buckskin bag containing corn meal, which she sprinkles over the whole pile, while she says a prayer for the pottery to be good.)

Continue to heap on more cedar and cover the whole pile, sides and top, with cakes of dried cow dung.

Light the pile, at the bottom, with a brand from the kitchen fire. The cedar and dung burn fiercely, with a clean, hot flame. When the flames die down and there is more heat in one place than in another, add fuel to the spot that is not hot enough and keep the flames burning evenly.

When the fire begins to die down all around the pile and only embers are left on the ground, let it go out.

Wait until the ashes are white.

Use a stick to lift out the pottery.

If the day has been still and the smoke has gone upward there will be little smoke clouding of the pots. Otherwise a wind can blow the smoke down and smoke the pots.

Julia Seton, in *American Indian Arts*, describes a slightly different method.

Build a good-sized wood fire and allow it to burn down to glowing coals.

Place a sheet of grating on the coals and crowd the pots, usually the work of several days, together on the grating — close but not touching one another, and upside down.

Build a circle of large flat cakes of cow dung around the grate and over the pots. Take care that the dung does not

touch the pots and that little vent holes are left for the circulation of air.

Build a hot fire of cedar around the manure. This will burn for about an hour.

Then smolder the fire with a tubful of horse manure which shuts out all the air and produces a dense white smoke.

This turns the clay black in about half an hour. The fire is by this time pretty well burned down.

Allow the pots to cool on the grate for a while, then on the ground for a while longer.

Dust to remove the ash and polish with a slightly greasy rag.

The tubful of horse manure poured over the fire is what produces the famous black pottery of San Ildefonso and Santa Clara pueblos. It was accidently discovered by Julian Martinez and Maria Martinez in 1920 when they were firing by the first described method. The Santa Clara Indians were already making black pottery; the Martinezes arrived at their discovery independently.

A digging expedition in 1909 to the Pajarito Plateau west of the San Ildefonso pueblo used men from the pueblo to help dig. Julian Martinez was one of these men and the head of the expedition requested that his wife, Maria, make a whole pot from one of the sherds, or fragments, found in the ruins. She made several pots and Julian painted the designs on them, copying the design from the potsherd. The bowl was covered with fine gray lines made from guaco, which is a common plant in the area. It had a pattern of a water snake, with square even designs representing the pueblo and the field around it. After firing, three pieces of the "new-old" pots were perfect, but some were completely black, like the Santa ˙Clara pottery. Julian Martinez finally decided that it was the smoke from the cow dung which turned those pots too near the edge black. The guaco on the other pots had carbonized perfectly.

The men on the archaelogical dig made plans for and built a museum in Santa Fe, New Mexico, some 20 miles from the San Ildefonso pueblo. The "new-old" pottery which Maria Martinez had made was shown there and bought by visitors. This was the beginning in 1920 of a world-famed pottery business.

Pueblo Pottery

Acoma is the southernmost village of the Rio Grande pueblos and is built atop a high mesa. It was the first village that the Spaniards saw coming up from the south. It glittered in the sunlight and the Spaniards thought they had found the famed seven cities of Cibola.

Acoma pottery is made of fine clay and sand, thin and hard, and nearly white in color; its designs are geometric (Figure 31). Acoma and pottery from Laguna, a neighboring pueblo, are similar.

Other Rio Grande pueblos include: Isleta, Sandia, Santa Ana, Zia, Jemez, San Felipe, Santa Domingo, Cochiti, Tesuque, Nambe, San Ildefonso, Santa Clara, San Juan, Picuris and Taos, the farthest north.

Cochiti pottery is creamy yellow, like that of nearby Santa Domingo. Cochiti designs are symbolic — black designs of lightening, clouds, birds, plants, checkered fields. At Santa Domingo the designs usually consist of realistic floral patterns and large birds (Figure 32).

At Zia pueblo, the pottery is lighter in color, some nearly white, others yellow-buff. The designs are frequently of animals — slender stylized birds and deer. The sun symbol originated at Zia pueblo (the symbol now used as the state insignia of New Mexico).

Santa Clara and San Ildefonso pueblos make the best-known polished black ware. The Santa Clara pottery is

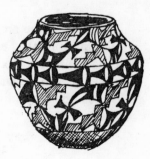

Figure 31

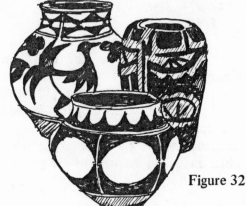

Figure 32

usually shiny black; wedding jars are more elaborate with flared rims and designs which are impressed. Santa Clara now is also making shiny red pottery (Figure 33).

Maria Martinez of San Ildefonso is perhaps the most famous individual potter and has received, among other honors, the medal of the American Institute of Architects and the French Palmes Academiques. San Ildefonso pottery is dull black on polished black (Figure 34).

Mica is used to temper the pottery in the pueblos to the north – Picuris and Taos. The pottery is unpainted, gold-tan in color and glitters from the mica imbedded in it. Jars and bean pots are common, with loop handles and lids on the bean pots.

Older women now make most of the pottery of the Zunis; the younger ones are making jewelry. A chalk-white slip is

common in Zuni pottery, with large brown-black designs and touches of bright red.

Frogs are sometimes modeled in relief, and other rain symbols; tadpoles and dragonflies are common. Geometric patterns include large scrolls edged with triangles. A deer with a white rump and a red heart line is a Zuni symbol.

Some of the best clay is found in Hopiland. When fired,

Figure 33

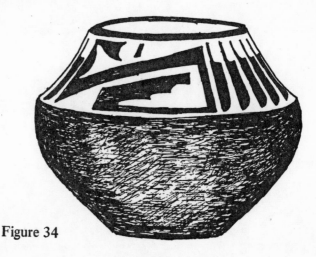

Figure 34

the color ranges from a creamy white to yellow and red-brown.

Hopis have developed a ware resembling a prehistoric pottery known as Sikyatki. This pottery was copied after an archeological dig in 1900. Decorated pottery is made only by the villages on the first mesa; utility pottery is made on the others.

15.
How To Make
Southwestern Indian
Pottery

To make a pot or bowl as the Indian makes it requires patience, experimentation, and a willingness to be pleased with crude efforts at first. The methods are deceptively simple; the skill must be acquired. The Indians use the material at hand, although they sometimes travel as many as thirty miles to clay deposits or to gather material for the colors they wish to use.

Clay

If you know of a local clay deposit, you may wish to collect the clay yourself. Even the best clay must be pulverized before it can be used. A hammer will crush the lumps — fine grinding may be done with a heavy rolling pin

The Indians used stones or wooden sticks for crushing, and the mano and metate (which they also used to grind corn) for fine grinding.

Clay may also be obtained commercially; the yellow pages list suppliers. Both low temperature and high temperature are usually available. The low temperature can be fired at home in an electric kiln; the high temperature must be fired commercially.

Sifting the Clay

The clay should be fine and smooth. Pueblo women strive for the consistency of wheat flour. After pulverizing, some impurities still remain — small pebbles or lumps of clay. These may be removed by repeatedly sifting or by tossing the pulverized clay in a winnowing basket. The lumps or pebbles drop back into the basket while the fine clay is blown onto a clean covering on the ground.

Storage of Clay

If you do not plan to make your pottery immediately, pulverizing and sifting should be done before the clay is stored. In the pueblos, clay was often prepared in the spring and stored, not to be used until winter when the pottery was made.

Tempering the Clay

Indian potters discovered that adding a tempering material increased the strength of their pottery. Sand was a commonly chosen material. For pottery that was thin and hard, a fine sand was the most desirable. The sand, too, must be cleaned and sifted. Mica was sometimes used as a tempering material and is a characteristic of Taos pueblo pottery. Finely crushed limestone or old broken pots (although these were usually saved for use in firing) and sometimes even plant fibers were

used. The tempering material gives the pottery added strength and lessens the chance of cracking during the drying and firing process.

In order to add the tempering material, first add water and knead the wet clay on a board or flat stone until it is like dough or putty. As you work, add the tempering material. You may have to make several batches to find just the right consistency. Too much sand or other tempering material makes the clay gritty and hard to work with.

Now the clay is ready. The Pueblo Indian builds her pottery by coiling it on a plate-like base.

Making the Pot

A simple round bowl with no design, for use as a cooking utensil perhaps, is made in the following way:

1. Choose a shallow bowl the size you wish your clay bowl to be. The Indian woman might use a basket.

2. Fill another bowl with water — you should work with wet hands.

3. Pat part of the clay into a flat tortilla-like shape and place it in the bottom of the bowl. Be careful that it is not too thin or it will crack and break during the drying and firing process.

4. Next, make a thick coil of clay and lay it around the rim of the "tortilla." Add another coil, on top of this one, making sure that the ends do not meet in the same place. Use the left hand to build the spiral, the right hand to control the shape (Figure 35). Add additional coils in the same way, as high as you wish to go. Be sure to pinch each new coil to the one below it so that they will stick together.

5. Using thumb and fingers, press the sides of the bowl to

Figure 35

the thickness you desire. If you want a bowl that is wider at the top, slope the coils outward. If you want a narrower bowl, press them inward.

6. For a bowl that has shoulders and slopes to a narrow neck, the middle coil should be thicker, to act as a second foundation for the upper part of the bowl. Otherwise, the bowl will cave in. The same is true for building large bowls.

7. To shape the pot, use a piece of broken pottery, holding it in one hand while holding the inside of the bowl with the other (Figure 36). The pressure of the hand inside the pot holds the wall of the pot firm while the pressure from the gourd or sherd pushes the clay into the desired position.

The lower part of large jars should be allowed to harden before the top is added.

Drying the Pot

A good drying day is a sunny day with low humidity. In the Southwest, a day's drying time is enough. In a moister climate, several days should be set aside for drying. Sometimes the pots will crack and be spoiled in the drying process. If a pot is not too badly cracked, patch it with clay, and smooth it with a piece of sandpaper or, as the Indians did, with a dry corncob.

Firing the Pot

Pots that have been dried and scraped are ready for firing if what you want is a plain utility piece. The color should not

Figure 36

change in firing — in open pit firing it may become smoke smudged but otherwise it will remain the approximate color it was when dry. See the description of firing on pages 94-96.

If, however, you want to decorate the pot, or to color the plain pot, there are additional steps to take.

Slipping the Pot

Slip is a mixture of water and colored clay. Common Indian colors used are white, tan, yellow or red. Powdered quartz and lime, mixed with clay and water will give a mixture like white cream. Bits of red brick, powdered, mixed with clay and water will make red. Soot and clay with water will give black. Apply a coat of the slip with a rag or brush (Figure 37), let it dry, and apply a second coat. The slip fills in the pores of the pot, giving it color as well as an even finish on which to apply decoration.

Also apply the slip to the inside surfaces of shallow bowls.

Figure 37

Polishing the Pot

Pots should be polished before they are fired. Allow the final coat of slip to become almost dry. A small, smooth stone is used to polish. In the pueblos of the Southwest these were special stones called polishing stones and were handed down from mother to daughter. Other smooth, hard implements will polish. The polishing takes many hours.

Painting the Pot

Although the yucca was commonly used as a paintbrush in the Southwest (see page 91), the Papago Indians used a stick and the Pueblo Indians used a feather. Slivers from the middle of the stump of a hickory tree make good paint brushes. These are seasoned heart wood. Cut and round a sliver and then chew the end into a soft brush.

For paint, the Indians used ground minerals and boiled plant juices. Guaco, a plant often used in the Southwest, was boiled and the syrup used both for sweetening of foods and for black paint. When the pot is fired the guaco burns and makes a black design.

16.
Indian Arts and Crafts of Other Cultural Areas

The Southwest, mainly Arizona and New Mexico, is the most important center today for contemporary Indian arts. It is in the Pueblo area, where ancient ways of life have changed little, that the richest varieties of traditional arts are to be found.

But in the Southwest and across the country, Indian artist-craftsmen are also evolving forms which reflect both ancient traditions and a changed way of life. They are taking what they can use from the white man's culture, appraising, integrating, rephrasing, to express their own heritage. Change is imperceptible in some crafts where centuries of meaning and utility still dictate the form. In other crafts, however, new forms have been found for old meanings and ancient designs for contemporary attitudes. Innovative approaches are used in which tribally prescribed styles are not abandoned

but neither are they held with rigid conformity. Indian silversmiths abstract elements from ancient traditions to make avant-garde statements with them. Ceramics, culturally inspired, may be innovative as well. Sculpture and painting move from the traditional to the abstract, from the conformist to the iconoclast, but seem always to spring from the meanings that are basic to the Indian.

The old is still shaping the new, and a revival of American Indian crafts is occurring across the country, with emphasis on traditional forms and earth-found materials.

Many Indian tribes no longer exist and are lost to history; many others have been displaced. In the East, tribes of the coastal regions and inner eastern areas beyond the Mississippi suffered great cultural decline during the eighteenth and nineteenth centuries. From Maine to Florida, once-great cultures suffered devastating losses, but in isolated areas along the coastal region remnants remain – now being strengthened and renewed. Tribal connections are being revived, traditions of beadwork, basketry, costume arts, and mask making are flourishing. From the northeast woods the ancient craft of basketry is being kept alive by modern craftsmen.

North American Indians across the continent have been weaving baskets for at least 9,000 years, coiling with willow, hazel and redbud, sewing and twining with split strands of the branch, plaiting with layers of wood stripped from pounded logs of oak, ash and hickory. Three distinct techniques evolved – plaiting, twining and coiling – coiling and twining among the western Indians, plaiting in the eastern regions. Common to most basketmakers is a simple plaiting technique for practical, everyday objects – traps for fish, baskets for carrying nuts and berries.

In the northeast regions, logs of oak, ash and hickory are cut and pounded until the wood separates into layers which are split for plaiting. The technique is simple, but time-consuming. Two sets of materials cross each other, passing

over and under those of the other set, producing the characteristic checkerboard effect. Different materials and thicknesses create variations.

Among the northeast Indians, the Algonquin tribes plait with split woods and coil with the sweet grasses of the region. The Iroquois split plait and twine with cornhusks. Using traditional weaving methods, it is in the decorative tech- niques and materials that the real regional distinctions are apparent.

Found among the Algonquin tribes are the decorative patterns of dyed splints of the Micmac, simple plaited designs of the Nauset, designs stamped with a piece of potato by the Mohegan. Unique here is the curlicue work of the Passamaquoddy, a twisted overlay strip.

The Iroquois, language-related to the Cherokee, share common basketry techniques — ash splint utility baskets, baskets for berry pickers and corn washing. Cornhusks reflect the Iroquois' perception of utility and beauty in nature. Medicine masks are made of cornhusks, with the rough husks deftly knotted; cornhusks are braided and sewn together for mats, or twined to make salt and tobacco bottles.

Beadwork flourished in the quillwork regions — where Indian craftsmen took the white man's trading beads and fashioned them into their own designs. European glass trade beads were in use in the eastern regions as early as 1675. Techniques included weaving, netting, spot-stitch and lazy-stitch sewing. In the Northeast, spot-stitch sewing — the technique of laying threaded beads in a design and sewing them in place — is used for the complex linear designs and stylized floral work. The Iroquois' embossed beading is a kind of lazy-stitch, the arching of the stitch emphasized by crowding the beads and raising the designs with padding. Sometimes combined with spot stitching on moccasins, Iroquois embossed beading is most common on early velvet pouches with floral designs.

Quillwork is being done in the northeast woods — the

smooth, shiny porcupine quills are soaked in water to become so pliable that the craftsman manipulates the spiny quills like embroidery floss, fashioning objects of great beauty with familiar woodland motifs.

Indian art is always functional. It is at the same time practical and mystical, and even in the mystique of it is a certain practicality. The powerful Iroquois falseface masks which were carved from living trees had a dual purpose, used not only as representations of "The Great One" with his broken nose, but also used by members of the Masked Medicine Society to cure the sick.

To the south, the Cherokees belong culturally to the southeast area, and today live in mountainous North Carolina as farmers and woodsmen. A growing craft movement is reviving traditional work in basketry and stone among them, and their skills are being renewed. Their tribal past is less clearly defined than some other groups, and their current work perhaps more contemporary. The impact of the colonists on their way of life was definite. Weapons, utensils, tools and colonial costumes were adopted by the Cherokees. Their original tribal costume belongs to a now-forgotten past.

Eastern Cherokee basket making had the beginnings of its revival in the 1940s, and new forms are continuing to evolve. Plaiting is a common technique — split white oak, river cane and honeysuckle vine are the weaver's materials. Blood root, walnut root and yellow root provide natural dyes. The Oklahoma Cherokees work with native materials to make baskets of wicker.

Plaited baskets characterize the southeast region, with some of the finest baskets made with the double weave that produces distinctive designs on two surfaces. Basket rims are often finished with a hoop and bound with hickory bark.

The wooden ceremonial mask of the Iroquois is carved of stone in the North Carolina mountains. Today stone pots with mask-like ornaments and stone implements mark the work of Cherokee stone-cutters, reviving an ancient craft.

The Choctaws of Mississippi, another of the original southeast culture group, are among the latest of eastern tribes to reassert themselves. Some excellent basketry is being made, including colorful baskets of native river cane with bold geometric designs.

The tribal arts of the Great Plains were linked to the eighteenth- and nineteenth-century buffalo-centered culture. By 1880, with the virtual extinction of the buffalo, patterns of tribal life began to disappear, too. Contemporary Indian artist-craftsmen have continued to preserve tribal traditions in beadwork, quillwork, costume work and in paintings of a vanished but colorful lifestyle.

Masters of adornment, the Plains Indians — in contrast to the northwest coast Pueblo and Iroquois Indians — rarely disguised themselves, rarely used masks. Deities were seldom impersonated, with the exceptions of the Bull Dancers of the Mandan, who wore buffalo heads, and the Fool Society of the Assiniboine, who in grotesque masks acted like clowns in obedience to a spirit's revelation.

The costumes of the Plains were elaborate — the Crow costume is typical. For the men, a shirt, leggings of hip length, moccasins, buffalo robe. Long dresses of deer or mountain sheepskin for women, with knee-high leggings and moccasins. Ermine skins and buffalo robes for gala occasions.

Hide painting, being studied and revived by Plains artists, was done on buffalo robes, tipi covers, clothing. Iron-laden earth clays yielded rich paints of brown, red and yellow; blacks were obtained from scoops of black earth. The clays were pulverized in stone mortars and then made sticky by a gluey substance. Paint pots were hollow stones or shells; early brushes were made from bone, horn or wood; later, tufts of antelope hair were mounted on a stick. The Hidatsa Indian first pressed his designs into the hide, then applied paint over them, finally setting the paint with glue. Glue outlined the patterns, and could be used without colors on part of a hide.

Designs were sometimes conventionalized, or they might

depict scenes from life. Often they carried sacred symbols for protection.

Realistic pictures drawn on robes or tipi covers recorded significant events in the owner's life — an exploit of war or a visionary experience. "Calendric" hides of the Dakota and Kiowas depicted tribal events. Not only utilitarian, the drawings were executed with skill and beauty.

Both men and women were artists — men painting realistic designs on the robes, shields and tipis, women painting geometrical figures on hide and doing all beadwork and quilling.

Decorative design flourished in quillwork and bead embroidery. Patterns were more complex and diverse than on rawhide containers and ornamented robes. Indian craftswomen succeeded in quilling bird forms, horses, and mounted braves in full regalia.

Beadwork developed on the Plains around 1830. Traders introduced large china and glass beads in great quantities. White and sky-blue in color, these early beads were nearly double the size of beads brought in later.

"Lazy" or "overlay" stitching was used in beadwork. In the lazy stitch, beads are strung on threads, which are fastened to the surface at the ends of short parallel rows. The result is similar to some types of quillwork, suggesting adaptation of the earlier technique to the new material. In the overlay stitch, strings of beads are tightly attached to the surface in close-set rows, using other threads to produce a smooth finish. The lazy stitch restricts the artist to angular designs; curvilinear figures are easily made by overlay stitching.

Overlay was the most popular technique in the early nineteenth century and was common throughout the area. The figures were geometric — triangles which rested on transverse strips, chains of right-hand triangles, bars and oblongs. A massive effect was frequently created.

With the introduction of smaller beads, a characteristically modern style was evolved — with tribal differences of both technique and style apparent. Dakotas, Cheyennes and Arapahos used the lazy stitch. The Blackfoot, Plains Crees, Sarsis and Flatheads used the overlay. The Plains Shoshones, the Gros Ventres, Assiniboines and the Crows made use of both techniques. In the south, where beadwork was used for trimming, the Pawnees preferred the lazy stitch, the Omahas the overlay.

Color had esthetic value and rich tribal meaning. In the beadwork of all tribes, white is a frequent background. The Arapahos used it exclusively, the Cheyennes added yellow, the Shoshones a light grayish blue. Only the Blackfoot showed a distinct preference for other background colors.

In warfare, religion and art, color had meaning. For the Dakotas, red was the sunset or thunder; yellow the dawn or the earth; blue the clouds, the sky, the night; green the summer.

To the Arapahos, black meant victory. To them, red meant blood, or man himself, or the red earth or rocks. Yellow was for sunlight; green for vegetation; blue for clouds, sky, smoke, distant mountains and night.

For the Crows, red was an abstraction — longevity or the ownership of property. White clay was a symbol of ablutions to produce a vision and knowledge of the future.

Today, young Plains Indians recreate canvasses reminiscent of hide paintings, and bead medallions in geometric designs that become part of ceremonial costumes for dances — sometimes traditional, sometimes the innovative native American ballet. Bead embroidery may employ the use of tiny cut beads, in overlay stitch, for an elegant, understated sparkle.

As Indians across the country look to their past for tribal traditions and inspiration, they dramatize their continuing sense of harmony with nature in choosing materials from

the land with which to fashion contemporary arts and crafts.

In California, there were once numerous tribal groups whose skill in basketry and featherwork remain unsurpassed today. By the end of the Gold Rush, this culture had all but vanished. Today there are only remnants, but among them California and Basin Region Indians continue to produce a limited number of superb baskets.

The Hupas and Yuroks of northwestern California made fine overlay twined baskets in which the wefts of conifer roots were covered with strands of glossy yellow bear grass or shiny black fern stem. Overlay strands might cover the entire surface or simply the decorative patterns. The half-twist overlay characterized the Yurok and Hupa baskets. Their uses were imaginative and varied — dance baskets, women's hats, cradles, baskets for cooking and storage.

In the central California region, baskets were both twined and coiled. The Pomos excelled in creating a diversity of forms, superior techniques and varied decoration. Pomo coiled baskets are famous, but are only one variety of this tribe. Spectacular ceremonial baskets featured spotted feathers of quail and woodpecker, feather mosaic decorations. Beads were a popular decorative item. Pomo twined baskets were basic utility items but the Pomos' decorative flair and high quality was evident. Plain and twill twine, three-strand and braided twine were combined with wrap twine to form large storage pieces. In the central California region, basketry was an unsurpassed art.

In the southern California desert region baskets are coiled with bundles of grass, rush stems, shredded yucca leaves and other fibers of the region. California baskets coil to the right, Arizona baskets to the left.

Mono Indians, working in basketry today, wind coils of grass stems clockwise. A unique form is the bottleneck, made with one-rod and three-rod coils, and decorated with red yarn or feathers.

Pima and Papago baskets are contemporary, and draw heavily on past traditions. Pima baskets are willow-stitched, designed with devil's claw fiber, coiled with narrow coils of split cattail stems. Designs are whorls or zigzags. Tiny less-than-an-inch pieces are made for sale.

Papago baskets are darker, stiffer and heavier than those of the Pomos. Coiled with bear grass or yucca, the Papagos do extensive work in basketry today. Effigies of animals or people are for sale; lifelike figures humorously and colorfully decorate baskets. Contemporary artists of the California and basin regions show a sense of tribal past, combined with contemporary awareness, a great feel for materials of the soil, and frequently in their designs, a uniquely Indian sense of humor.

The Basin Region, extending from Arizona to Oregon and including Utah and Nevada, was a region of Indians for whom the most important implements were baskets. Pauites, Utes, Bannocks and Shoshones made plain twine baskets. Contemporary craftsmen embellish older styles.

Farther north, in Washington and Oregon, crafts have also had a cultural continuity, particularly in sculpture and basketry. The Oregon-Washington area contains many small tribes and many kinds of baskets. The region is noted for fine-twined baskets with overlay decoration. The Makahs of the Olympic Peninsula make bowls and baskets, characteristically covered with white squaw grass and colored figures.

A complex of tribes on the northwest coast produced astonishing sculptural forms — wood their natural material, carving their art — totem poles, powerful articulate masks of wood, boats, wooden utensils, ceremonial items. A social style both ostentatious and capitalistic gradually declined, but its art forms survive and are being reconstructed by contemporary Indians — forms of totemic sculpture, modern interpretations of ceremonial masks, carvings of cedar, baskets of spruce.

Contemporary Indian arts and crafts across the country

continue to reflect strong and varied tribal traditions, many basically unchanged for centuries. They are also reflecting an unchanging belief in man's need to bring his existence into harmony with nature, to respect his environment. This spiritual strength of the Indian's concepts gives continuity to his differing tribal lifestyles, and an added dimension of interest to his work as an artist and craftsman.